THE TWENTIETH CENTURY
GREENWICH

BARBARA LUDLOW & JULIAN WATSON

SUTTON PUBLISHING

GREENWICH LOCAL HISTORY LIBRARY

First published in the United Kingdom in 1999 by
Sutton Publishing Limited · Phoenix Mill
Thrupp · Stroud · Gloucestershire · GL5 2BU
in association with Greenwich Local History Library

British Library Cataloguing in Publication Data
A catalogue record for this book is available from the British Library.

ISBN 0-7509-2134-X

ALAN SUTTON™ and SUTTON™ are the
trade marks of Sutton Publishing Limited

Typeset in 11/14pt Photina.
Typesetting and origination by
Sutton Publishing Limited.
Printed in Great Britain by
Redwood Books, Trowbridge, Wiltshire.

Contents

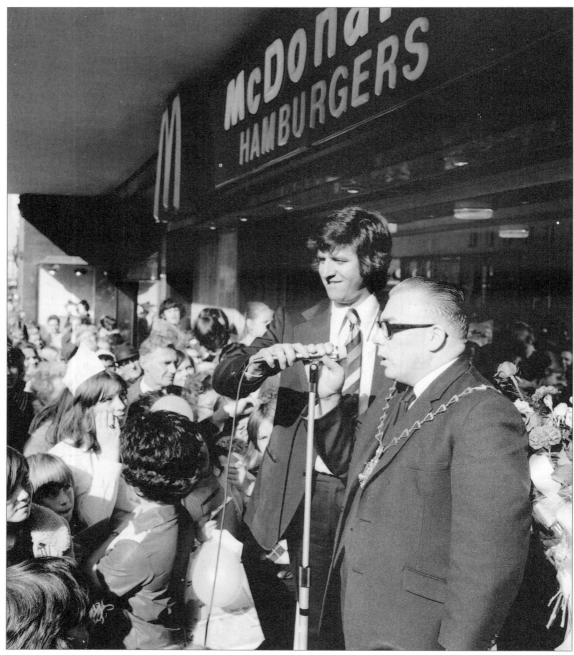

The first in England! The opening of McDonald's Restaurant, 56–60 Powis Street, Woolwich, 12 October 1974. Disc jockey Ed Stewart, now a BBC Radio 2 presenter, and Len Squirrel, Mayor of the London Borough of Greenwich, opening England's first McDonald's Restaurant. Customers had been able to sample the new fast food several days before the official opening and, as had been predicted, loved what they tasted. McDonald's researchers had picked Woolwich from among hundreds of other towns because it had the population mix that they were looking for. 'And', said Robert Rhea, McDonald's Managing Director, 'It's such a wonderful place.' The first manager at the Woolwich restaurant was Paul Preston. In October 1996 he was appointed Chairman of McDonald's Restaurants Ltd. The Woolwich McDonald's was also their 3,000th restaurant worldwide. A commemorative plaque, unveiled in November 1974 by the Chairman and Founder Ray A. Kroc, is on the wall of the Powis Street restaurant.

Introduction

The year 1900 opened a century of change and innovation even greater than the previous hundred years. People who had lived through the introduction of steam trains, gas power and lighting, electricity, huge factories, and the explosive growth of London into the surrounding countryside would have found it difficult to imagine the further changes about to take place. The size and complexity of London made it impossible to govern efficiently, with the traditional parish councils or vestries, and there was a bewildering array of these, boards of works, poor law unions, a Board of Health and a School Board. The County of London and the London County Council had been created in 1889, and then in 1900 the newly formed metropolitan boroughs came into operation. Density of population dictated the size of these new authorities. Bermondsey and Shoreditch were small boroughs with little open space. Greenwich and Woolwich boroughs on the other hand were large areas made up of towns, industrial sites, villages and farms. The new Borough of Greenwich consisted of a small part of Deptford around St Nicholas Church and the Green, Greenwich Town, and the parishes of Charlton and Kidbrooke; the latter two were still rural in character with many acres of fields and open land.

Industrial Woolwich and North Woolwich were amalgamated with Plumstead and the very rural area of Eltham. Plumstead's farmlands and orchards had already been developed in the previous century, mainly to house workers from the burgeoning Royal Arsenal at Woolwich and London commuters. The wild and bleak Plumstead marshes, with their extraordinary population of wading and migratory birds, had quickly become part of the same industrial empire.

The large tracts of undeveloped land in the two boroughs were to be extremely important for the creation of new estates to house those who had to endure disgusting and extremely unhealthy living conditions in the old riverside areas. However, these changes did not happen immediately and local people still thought of themselves as Kentish rather than as Londoners, even though the area had ceased to be in Kent after 1889.

Between 1900 and 1914 few changes took place in the two boroughs although the Borough of Woolwich enriched its landscape with some very fine new public buildings: the town hall, new libraries, swimming baths and a power station. However, the decision taken at the end of the previous century to link the north and south banks of the Thames with three tunnels, in addition to the Woolwich Free Ferry, was to have considerable impact on the local economy. It was hoped that the greater mobility of labour would ease unemployment, and that the construction of these crossings would bring about the clearance of areas of very poor housing. No further crossings would be made until 1967 when the Blackwall Tunnel was duplicated and more recently, when the Docklands Light Railway tunnel was put through from the Isle of Dogs to Greenwich.

The boroughs of Greenwich and Woolwich were blessed with magnificent historic buildings, some of which were still being used for their original purpose. The outstanding exception, and the oldest, was the Great Hall of Eltham Palace. The hall and the moat bridge, both built *c.* 1480, had survived the Civil War but had become part of a farm. The government had paid for repairs to be carried out in 1912 in order to save these sole surviving parts of the great Plantagenet palace. The turning point

was in 1933 when the palace was leased to Sir Stephen Courtauld. He restored the Great Hall and built on to it an astonishing art deco mansion which is now, for the first time, open to the public.

Greenwich possesses a remarkable collection of royal buildings as a result of its position on the Thames. If Humphrey, Duke of Gloucester, had not built his palace here in the early fifteenth century then the history and appearance of Greenwich would have been entirely different. There would have been no Greenwich Park, Royal Naval College, Royal Observatory or National Maritime Museum. When Charles II demolished the great Tudor palace he intended to build an expensive replacement but the project was not completed. It was not until 1694 that the decision was made to build the Royal Hospital for Seamen on that site. The four blocks of the beautiful home for seamen pensioners, designed by Christopher Wren, stayed in use until 1869 when the hospital closed and the remaining pensioners were moved out. In 1873 the buildings became the Royal Naval College. Greenwich people in 1900 would have been astounded by the idea that this remarkable complex would be put up for sale. When this happened in the 1980s rumour and speculation were rife. Now the future of the 'Old Royal Naval College' seems secure with a new population of university and music students.

The Royal Observatory in Greenwich Park was, in 1900, the most important observatory in the world. Founded in 1675 it had been at the forefront of research to determine longitude, and in 1884 the Prime Meridian was established there. In 1833 the Time Ball came into service, falling at 1.00 p.m. every day to signal the exact time to the multitude of vessels making their way up and down the river. The Time Ball became as well known in Greenwich as the 1 o'clock Gun was in Woolwich.

The Queen's House, in 1900, was being used for a quite different purpose from that intended by its royal builder. Constructed between 1616 and 1662 this beautiful Palladian building, designed by Inigo Jones, spanned the highway to Woolwich, which ran along the northern boundary of Greenwich Park. After Greenwich ceased to be a royal home the Queen's House was a 'grace and favour' home until 1806 when it became the Naval Asylum School. Colonnades and balancing wings were added and in 1821, via an amalgamation of naval schools, it became the Royal Hospital School. Other buildings were added, including a large gymnasium of 1873. This school seemed to be a permanent part of the Greenwich landscape at the opening of the twentieth century but the school, like so many Greenwich institutions, was far from immune to change.

On the hill between Greenwich and Woolwich stood Charlton House, a magnificent Jacobean house. Built between 1607 and 1612 it was still, at the beginning of the century, the home of the Lord of the Manor of Charlton. The Maryon-Wilson family owned a large amount of land in Charlton and employed many local people. Charlton was growing fast but much of the growth was down the hill on and around the Charlton marshes. The panoramic view from the house which once would have been of peaceful marshlands and grazing cattle was now predominantly industrial. The First World War, suburban growth and, possibly, the formation of the London County Council and the new boroughs with new housing powers were factors that would have prompted the Maryon-Wilson family to move further away from London. The family left Charlton in 1917, never to return.

And so down-river to Woolwich. Since the sixteenth century this riverside town had housed 'Crown' industries which had strongly fashioned its development. The Royal Dockyard had closed in 1869 but the land was still owned and used by the government. The largest government establishment, the Royal Arsenal, continued to grow at a formidable pace, engulfing the wild, desolate and beautiful Plumstead marshes. The Arsenal, founded at the Warren in 1696, became the largest munitions factory in the country. During the First World War it employed about 80,000 workers, and the men and women who came to work at the Arsenal from all over the country needed homes. This need was to result in hundreds of temporary and permanent houses being built on some of the large areas of open land in Eltham. This wartime demand hastened the urbanisation of the village of

Eltham although it still contained many quaint and ancient cottages. In 1918 Eltham was still predominantly rural but the pace of development in the inter-war years was to be very fast.

At the opening of the twentieth century Woolwich probably contained almost as many soldiers as it did civilians. Barracks of various regiments were much in evidence although the Royal Artillery was the largest and most obvious military presence. The magnificent façade of the Royal Artillery Barracks, built 1778–1802, looked across Woolwich Common towards the fine buildings of the Royal Military Academy where cadets trained to be officers in the regiment.

The Borough of Greenwich has the longest river frontage of all the London boroughs. The river was the lifeblood of these communities. It played a particularly important part in the development of local industry. As docks spread over the old Thames marshlands it seemed at one time that Greenwich's marshes would be used for the same purpose. However, Greenwich's distance from Central London and disagreements among landowners prevented docks being established here. Instead the riverside areas were taken over by a remarkable diversity of industries. However, until 1965, part of the Metropolitan Borough of Woolwich was on the north bank of the Thames. North Woolwich had been part of Woolwich since at least the Anglo-Saxon period and was an important factor in the development of ferry services, which have been such a feature of Woolwich's history. It was in North Woolwich that the royal group of docks was built between 1855 and 1921. It was from North Woolwich that the crews of the Woolwich Free Ferry made their heroic all-night trips on the terrible night of 7/8 September 1940 to bring bombed and burned-out families to the southern shore to emergency accommodation. This historic link across the Thames was broken with the reorganisation of London government in 1965 when North Woolwich became part of the new London Borough of Newham.

Deptford, Greenwich and Woolwich had been called the three towns of north-west Kent. Deptford and Woolwich were old-established industrial towns but it was not until the middle of the nineteenth century that industry began to dominate the riverside areas of Greenwich. In 1847 Greenwich was described as 'a place of but few manufactures'. There was little on Greenwich Peninsula before the late 1850s. A large rope and sail works at Enderby's Wharf burnt down in 1845 leaving Francis Hill's chemical works on the opposite side of the peninsula as the only factory on the Greenwich marshes. In 1854 wire and cable makers moved on to the Enderby site and it was there that the first successful transatlantic telegraph cable was completed in 1866. By 1900 Telcon at Greenwich, Johnson and Phillips at Charlton and Siemens at Woolwich were among the foremost cable and electrical manufacturers in the country. The new resident community on the peninsula was surrounded by a variety of industrial works, which included gas, chemicals, soap, barge building and repairing, linoleum and cement. The marsh dwellers lived with smoke and a mixture of smells – many quite unpleasant. However, they had only to walk up the hill to be able to enjoy the peaceful countryside of Charlton, Kidbrooke or Eltham. In 1900 the Medical Officer of Health for Greenwich wrote, 'It is hoped that ultimately the marshes when built upon will become one of the best parts of East Greenwich'. He lived to see his dream founder but maybe the development of the Dome and the Millennium Village will go some way to fulfil his prophecy.

Three other important engineering works were founded away from the riverside. Two were established in the rural surroundings of early twentieth-century Eltham. In 1919 Walter Grafton moved his engineering works from Well Hall to Footscray Road in Eltham. This was after he had agreed to build a low factory with a façade that looked more like a small castle than an engineering establishment. Tennis courts in front made it look even more like a country house. It blended perfectly with the rural landscape. In 1988 it was demolished and a B&Q store stands on the site. Stanley's, the tool and instrument makers, moved into a long, low building in Avery Hill Road in 1916, blending in easily with the surrounding fields.

H.H. Collier made the Matchless motorcycle in Plumstead in 1899. It later became AJS Motorcycles and then, in 1937, Associated Motorcycles. At the height of production over 1,000 people worked in the factory on the corner of Burrage Road and Maxey Road. The business was taken over by Norton but closed shortly after, and the buildings were demolished.

In 1918 women left their wartime jobs to make way for returning servicemen. However, although the industrial structure was still in place many of the jobs were not. This was particularly true in the Royal Arsenal where the high output necessary to maintain the war was no longer required. Unemployment blighted many local communities. In the 1920s local councils pushed forward public works and slum clearance programmes. This was in response to the unemployment and housing problem and also to the government's promise of 'Homes fit for heroes'. New housing estates were built to rehouse families from old and insanitary housing. Greenwich Baths (now the Arches Leisure Centre) in Trafalgar Road was built in 1928 as part of the public works programme to alleviate local unemployment.

London's workhouse system had come to an end in 1929 but claiming the far from adequate unemployment benefit was an unpleasant and humiliating experience. Officials tended to treat the unemployed as though the loss of jobs was their fault rather than seeing them as victims of a global depression. This was often an intolerable burden on top of the suffering endured during the war. There were other measures to help the unemployed. The Trafalgar tavern in Greenwich was used in the late 1930s as an unemployment centre. For one penny a week unemployed men could attend classes, play sport, and have cheap meals. No provision was made for the men's families, of course.

In many ways the depression did not affect the south-east as badly as other parts of the country. It was here that the construction industry first began to expand. New private semi-detached houses, priced between £330 and £1,000 according to area, began to appear. 'Ideal' and 'Wonderhomes' rapidly appeared and soon Shooters Hill, Kidbrooke and Eltham sported new estates of houses with distinctive leaded light windows and 'Tudor' styling. The growth of these estates was extremely rapid, engulfing huge areas of farmland and threatening to cover the whole summit of Shooters Hill. This would almost certainly have happened but for the intervention of the LCC to preserve the beautiful woodlands on the hill.

In 1933 the boys of the Royal Hospital School marched out of the buildings at Greenwich and travelled to their new school buildings at Holbrook in Suffolk. The training ship *Fame* which stood on the north side of the Queen's House and was a prominent feature of the Greenwich landscape was dismantled. In the following year an Act of Parliament was passed to establish a National Maritime Museum. The school buildings, including the Queen's House, would be restored to house the new museum. King George VI travelled down the Thames to open it on 27 April 1937, just a few weeks before his coronation on 12 May. At the same time the government had taken another very significant decision: the Royal Observatory would be moved away from Greenwich where environmental problems were impeding its work. However, this move did not take place until after the Second World War.

The declaration of war on 3 September 1939 was no surprise except to the most optimistic. Since 1937 local councils had been drawing up their civil defence plans and the government had distributed gas masks and Anderson shelters. Public air raid shelters were planned and the Barrage Balloon Unit at Kidbrooke was busier than ever. Trenches were dug across open spaces like Blackheath to prevent the landing of enemy aircraft, and sandbags began to appear around essential buildings. There was also the huge task of evacuating London's schoolchildren to safer areas. It was assumed that, as soon as war was declared, the Luftwaffe would blitz London and other major cities. Thousands of children left their homes in September 1939 and travelled out of London not knowing their destination or the names of their temporary foster-parents. The children

from the boroughs of Greenwich and Woolwich were sent into Kent and Sussex. To their delight many of the children found themselves at the seaside – a curious decision considering the real threat of invasion. Many weeks passed, the sky remained empty of bombers and the children drifted back home as the initial alarm subsided.

Other changes were taking place to the local landscape as allotments appeared in parks, even on the lower slopes of Greenwich Park. Land awaiting development was ploughed up, and it was not unusual to see vegetables growing on what had been the grass verges beside roads. Garden gates and railings disappeared rapidly for the war effort. Most were never used but the effect of this campaign can be seen throughout the borough today.

On Saturday 7 September 1940 the bombing of London began. The sirens sounded in the middle of the afternoon, followed by the all-clear. In the evening the sirens sounded again and the devastating night bombing began. London was bombed every night until 2 November. Almost immediately the second evacuation of schoolchildren began. Schools already in Kent and Sussex moved to safer areas in the West Country, Wales and the Midlands. By late May 1941 the concentrated bombing of London and other cities was considered to be over. From then until the first half of 1944 day and night raids took place spasmodically.

Factories, churches and public buildings were destroyed or badly damaged. Hundreds of houses were uninhabitable and the families had to be taken into rest centres. The councils requisitioned empty houses so that families might be rehoused. Although privately owned these properties were added to the council's stock for the duration of the war. They were either returned to their owners at the end of the war or bought by the local authority. A few still belong to Greenwich Council.

The bombing raids had badly damaged the boroughs of Greenwich and Woolwich. The process of regeneration took a long time and involved considerable changes to the local landscape as houses were built to accommodate families whose homes had been lost in the war. New homes were built on bomb-damaged areas such as the Barnfield Estate, others on land released by the government such as the Ferrier Estate. Areas of poor housing like the St Mary's district of Woolwich were redeveloped, and areas of farmland were further diminished as Woolwich Borough Council built Coldharbour Estate in 1947 and completed Horn Park Estate in the 1950s. The former was built on the fields of Coldharbour Farm, the latter on one of the old parks belonging to Eltham Palace.

Manufacturing industries began to move away from the two boroughs, producing unemployment and riverside dereliction. The economic nadir of the area was in 1967/8, with the closure of the Royal Ordnance factory in the Arsenal and then the sudden closure of the giant Siemens factory at Woolwich. The effects of these closures are still being felt in 1999. However, the closure of the Royal Ordnance factory and the subsequent release of land on the Plumstead marshes led to the development of the brand new community of Thamesmead. The Abbey Wood Estate had been built in 1956–9 on land previously released from the Arsenal but Thamesmead is a much larger concept and is still growing. Although it is a new estate some features from the Arsenal, such as the 'Tumps', have been incorporated.

Transport changes have brought benefits but have also been the source of major concerns in some of the local communities. In order to improve traffic flow some very contentious schemes have been proposed. Major motorway schemes were planned from the 1960s, which would have devastated Eltham, Greenwich Park and town centre, and Blackheath Village. Fierce opposition from local amenity and historical societies caused these road schemes to be abandoned. Plans for the more recent East London River Crossing, which would have blighted areas of Plumstead and ruined the peace of Oxleas Wood and Woodlands Farm, seemed unstoppable but local opinion, which was very effectively and bravely organised, caused this destructive route to be abandoned as

well. However, the Rochester Way Relief Road was constructed, which did at least bring relative peace to residents who lived beside the old Rochester Way.

In 1966 the new Woolwich Ferry boats, introduced three years earlier, began to operate from a terminal further west than the original site. Traffic for the ferry now approached from John Wilson Street, a dual carriageway road, or from Woolwich High Street. The moving of the terminal eliminated the terrible traffic congestion in Powis Street and Hare Street. In 1967 the Blackwall Tunnel Southern Approach Road and the second bore of the Blackwall Tunnel opened, relieving the discomfort and delays caused by two-way traffic in the old tunnel which had been designed in 1897 for pedestrians and horse-drawn vehicles. However, regular users of the tunnel in the 1990s would probably dispute that the discomfort and delays had been relieved.

In 1999 the Docklands Light Railway extension from the Isle of Dogs to Lewisham via Cutty Sark station in Greenwich Church Street, and Greenwich station, will open. The Docklands Light Railway will improve the borough's public transport infrastructure and put Greenwich, Deptford and Lewisham on the London Underground map for the first time. The Jubilee Line from Central London to North Greenwich station on the Peninsula is also due to open in 1999 in time for the opening of the Millennium Dome, and will be the first London Underground line to reach Greenwich.

Greenwich already had a major tourist attraction in the National Maritime Museum, which had opened in 1937, but in 1957 the old clipper ship, the *Cutty Sark* in its new dry dock near Greenwich Pier, opened to the public. The dismal area of Dodd's Wharf near the *Cutty Sark* was cleared and landscaped to form Cutty Sark Gardens. The northern end of Greenwich Church Street where it used to meet the river at Garden Stairs disappeared as did Billingsgate Street, another ancient part of Greenwich. Change seemed to be endless. The Royal Observatory, which had been operating in Greenwich since 1676, began the slow move to Herstmonceaux Castle in Sussex between 1948 and 1954, leaving the old buildings empty. The buildings became in the 1960s the Old Royal Observatory Museum, an immensely popular visitor attraction.

The Royal Military Academy at Woolwich in its imposing building on Woolwich Common amalgamated with the Royal Military College at Sandhurst in 1945. The cadets left Woolwich where they had been trained as Royal Artillery officers since 1741.

Stephen Courtauld and his wife left Eltham Palace in 1944 having not only restored the Great Hall but also having built the remarkable house adjoining it. The buildings were taken over by the Royal Army Educational Corps. The Great Hall was opened to the public but there was no access to the Courtauld House. The Ministry of Defence gave up the buildings in 1992, handing them over to the care of English Heritage. After considerable restoration and refurbishment both the hall and the Courtauld House were opened to the public in 1999.

The story of Greenwich in the twentieth century has not just been one of decline and closure. Closures and change have brought opportunities for economic development. The centre of Greenwich is now a World Heritage Site, which will intensify its attractions to visitors. The riverside areas are going through a process of change, with new houses being built and opportunities for leisure being created. The decline of manufacturing industry on the Greenwich Peninsula has led directly to the opportunities created by the Millennium Dome and the Millennium Village. The closure of the Royal Arsenal has made available for refurbishment and re-use a large collection of unique historical buildings dating from 1696. Eventually the Arsenal will become part of Woolwich town centre, stimulating the economic revival which has been so badly needed. The twenty-first century should be very exciting but quite different from any that have preceded it.

The Vanishing Countryside

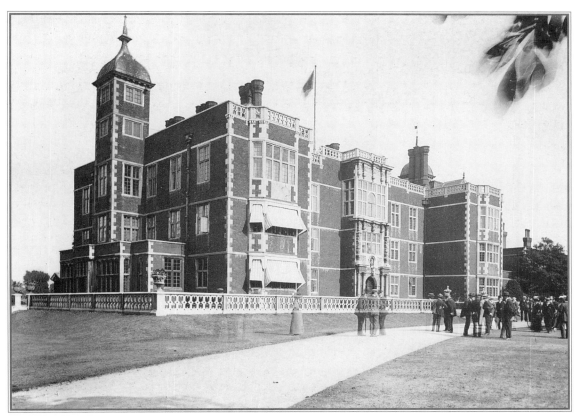

Charlton House, 1911. A visit to the house by members of the Kent Archaeological Society. Charlton House was still a private residence at this time, but the Maryon-Wilson family had given the society permission to look around. This was a unique opportunity because soon the house and its contents would be sold and no-one would have the chance again to see the interior with its contents. This photograph also shows the exterior in its original condition. In the Second World War the wing of the house in the foreground was badly damaged and had to be rebuilt.

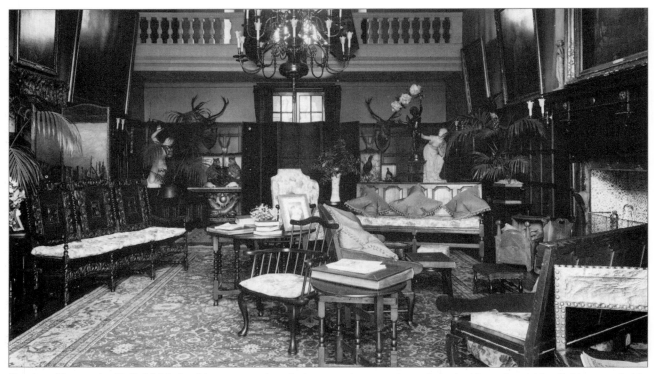

Charlton House: the Hall, 1909. In this year a series of photographs was taken of the inside and outside of this remarkable Jacobean house while it was still the home of the Maryon-Wilson family. These photographs are a very good record of the furnishings before the contents were sold. The images contrast strongly with the essentially functional interior of the house today. Only a few interiors showing the principal rooms have been chosen to give a flavour of this remarkable house during its last few years as a private residence. The Metropolitan Borough of Greenwich bought the house and park in 1925 and converted it into a museum, art gallery and library. The house is now a flourishing community centre. Here the hall, with its conglomeration of furniture, looks quite different from the present entrance hall to the community centre.

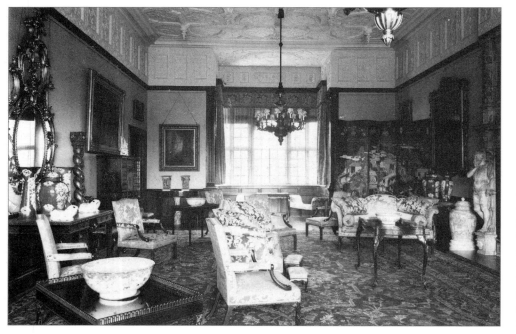

Charlton House: the Grand Salon, 1909. The Grand Salon is instantly recognisable because of the remarkable contemporary fireplace on the right-hand side of the picture. The fireplace survives intact and is one of the most splendid features of the house.

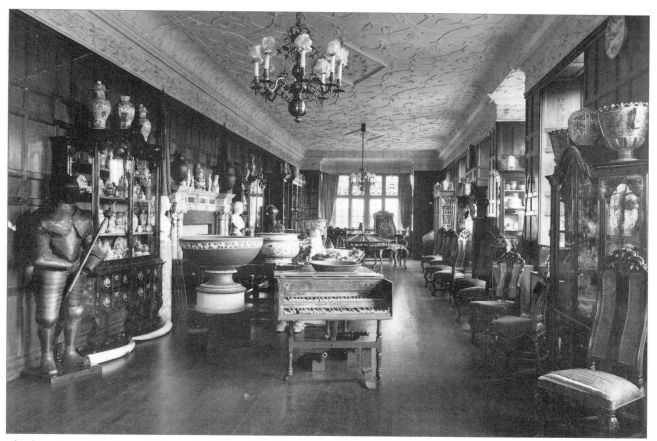

Charlton House: the Long Gallery, 1909. Even full of furniture, a harpsichord and suit of armour the length of the gallery is most impressive.

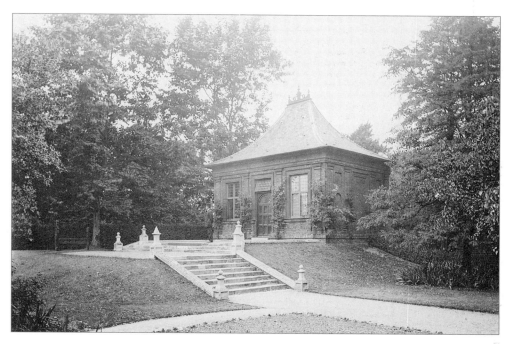

The Summer House at Charlton House, 1911. A fine photograph by a Kent Archaeological Society photographer of the delightful summerhouse in front of Charlton House adjacent to what was once the village green. This was taken on the day that the Kent Archaeological Society visited Charlton House and church. This lovely building of *c.* 1630, which has been attributed to Inigo Jones, was converted into a public lavatory in 1936.

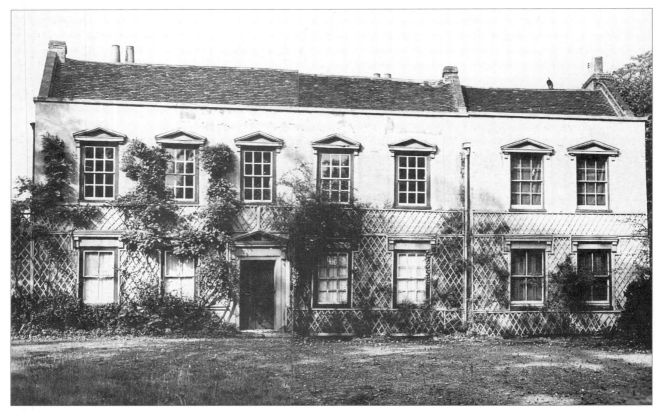

Springfield House, 245 Charlton Road, 1939. This seventeenth-century house stood opposite Charlton House until its demolition in 1948. During the 1930s Greenwich Borough Council purchased it together with four other old houses which stood between it and Victoria Way. The land was needed for the council's housing programme, which was held up by the Second World War. In 1951/2 the Springfield Estate, consisting of nine tower blocks, was built on the slopes of the hollow.

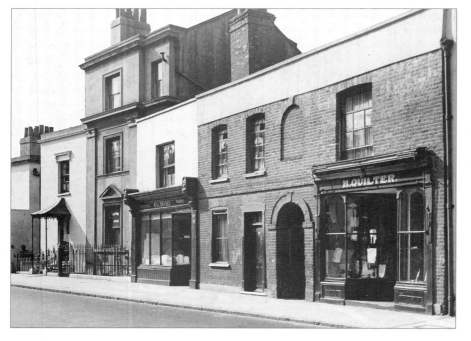

The Village, Charlton, *c.* 1939. This small group of buildings, nos 43–51 The Village, dates from the nineteenth century. Until fairly recent times The Village contained all the shops associated with a village street. The tallest building and the small cottage with an iron porch, nos 43 and 45, were built in the first half of the last century but have survived redevelopment. The terrace with R. Hoare, monumental mason, and H. Quilter, ladies' outfitter, together with other old buildings, had been demolished by 1970. Modern housing replaces them. In the early 1970s an archaeological excavation on the site revealed many old domestic utensils including some from the Tudor period.

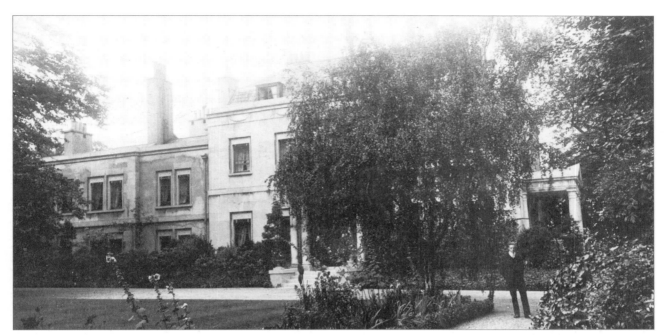

Woodlands, 90 Mycenae Road, Blackheath, 1907. This house was built in 1774 for John Julius Angerstein, the chief reformer of Lloyd's of London. In 1796 it was described as 'A charming small villa' but in 1800 the west wing was added. This is clearly shown in the photograph. The portico on the the eastern side of the building was the original entrance but in 1819 the present entrance in the middle of the 1774 house was added. The Angerstein family left Woodlands in 1873 and it became the home of William Bristow. Sir Alfred Yarrow the shipbuilder bought the house in 1894. Yarrow moved his shipyard to the Clyde in 1906/7 and the family left Blackheath, but did not immediately sell Woodlands. Just before moving away Sir Alfred had photographs taken of the house, grounds and staff. Each member of the domestic staff was presented with a splendid album as a keepsake. Between 1923 and 1967 Woodlands became a convent. It was bought by Greenwich Borough in 1967 and today houses Greenwich Local History Library and Woodlands Art Gallery.

The staff of Woodlands, Mycenae Road, Blackheath, on the front steps, 1907. Some of the staff went to Scotland with the Yarrow family, including Charlotte Brace (second from right), whose son James Black of Belvedere, Kent, still has his mother's album. On a recent visit to Woodlands Mr Black kindly gave permission for two of the photographs to be reproduced. Charlotte was recruited at the age of fourteen from a local school by Lady Yarrow. In 1907, when she was seventeen, Charlotte travelled to Scotland with the family and eventually became their cook.

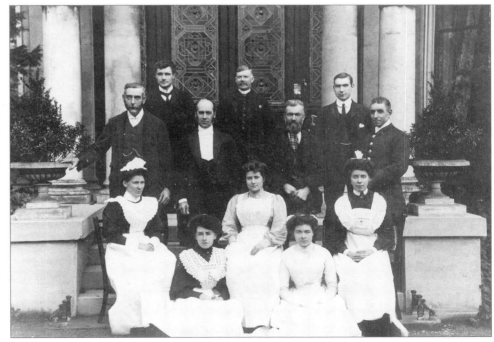

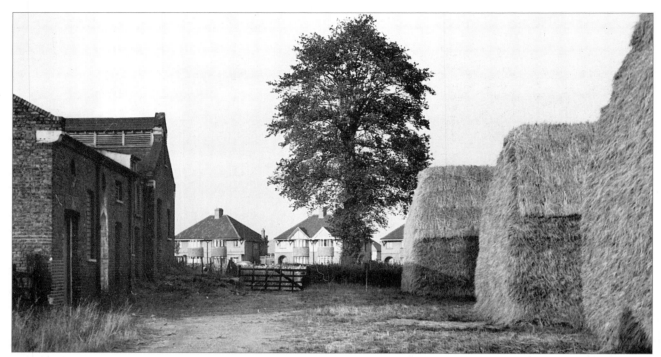

Upper Kidbrooke Farm, Brook Lane, August 1937. Change looms in the background of this photograph taken by A.R. Martin as ribbon development takes place along the Rochester Way. The haystacks and farm buildings owned by the Express Dairy would be engulfed by housing development. However, the planned housing for this site was not built until after the Second World War.

Rochester Way, Kidbrooke, 1938. A.R. Martin who diligently photographed the disappearance of rural Kidbrooke in the 1930s has here recorded the imminent disappearance of yet another plot of farmland. A fine new public house, the Dover Patrol, will be built on this piece of land. In the background can be seen a contrast between the old rural landscape and the new suburb: farm buildings on the right and 1930s houses in Kidbrooke Park Road on the left. The Dover Patrol was built as a large roadhouse to service travellers on the new Rochester Way. The pub with its splendid art deco interior was closed soon after the building of the Rochester Way Relief Road in the 1980s and was burned down in November 1990. Rosse Mews stand on the site today.

The Pond, Lower Kidbrooke Farm, 1938. In icy winters local people could put on their skates and use this pond as an ice rink. Today we would probably treasure it for the teeming life that it must have contained. In the 1930s it was described as 'Particularly nasty, often covered with green weed'.

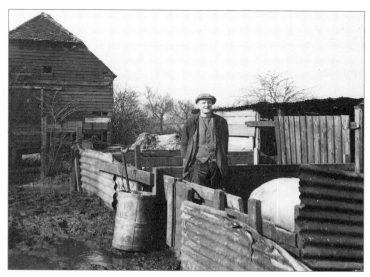

The pigman of Lower Kidbrooke Farm, 1938. This farm was often known as Stud Farm because of its association with Thomas Blenkiron, racehorse owner of Middle Park Farm, Eltham. The lower farm stood just to the north of Kidbrooke Station and to the east of Kidbrooke Park Road. This photograph taken by A.R. Martin is a melancholy record of Kidbrooke's farmlands just before they were overwhelmed by development. Across the way from the farm was a Royal Air Force Depot – the officers' mess stood adjacent to the piggeries.

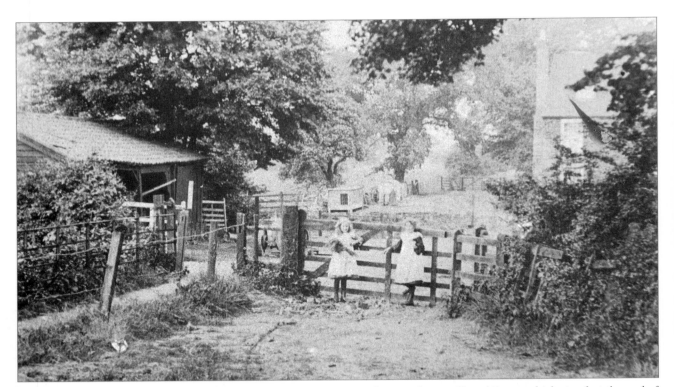

Chapel Farm, New Eltham, 1901. This tranquil and idyllic photograph was taken at Chapel Farm, which stood at the end of Chapel Farm Lane (now Court Road). The farm was, at one time, home to the Eltham Cricket Club whose most prominent member was Dr W.G. Grace. Today most of Eltham's farms are only remembered in street names. Chapel Farm Road borders the Coldharbour Estate, which was developed by Woolwich Borough Council from 1947. With this development the last remains of Chapel Farm disappeared.

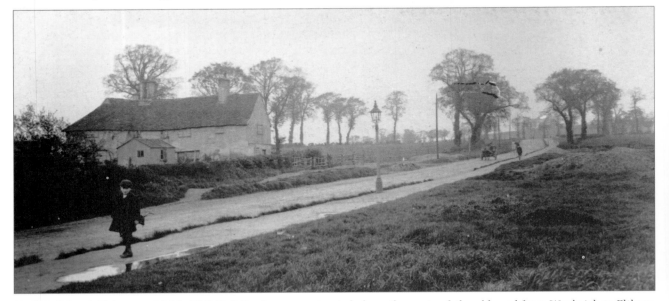

Well Hall Road, Eltham, *c.* 1905. Well Hall Road was constructed along the route of the old road from Woolwich to Eltham Village. In this picture, looking towards Woolwich, there is very little to be seen but pleasant farmland. The ancient and interesting houses stood between the Tudor Barn and the present Well Hall roundabout. Quaintly known as Nell Gwyn's Cottages they were demolished in 1923. Shops now stand on the site.

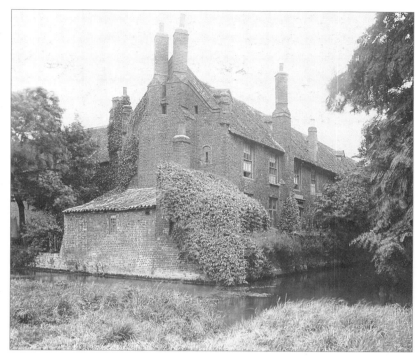

The Tudor Barn, Well Hall, Eltham, *c.* 1910. This remarkable building dates from the early sixteenth century. It was not built as a barn since it has Tudor fireplaces on both floors. Almost certainly it was part of the Well Hall estate of William Roper and his wife Margaret More. The main part of Roper's house was in the centre of the moat but was demolished in 1733 when Sir Gregory Page built Well Hall House outside the moated area. The Tudor Barn, on the outer edge of the moat, survived and became part of the farm buildings attached to Well Hall Farm. In 1930 Woolwich Borough Council bought the house and outbuildings, including the barn. They restored the Tudor Barn and converted it into an art gallery and restaurant. However, Well Hall House was considered to be structurally unsound and was demolished. The moat and gardens are incorporated in Well Hall Pleasaunce. The Tudor Barn is a bar and restaurant, and the first floor may reopen soon as an art gallery.

Well Hall House, Well Hall Road, Eltham, 1916. The trams started to rattle past this house in 1910. It was then occupied by Edith Nesbit, the famous children's writer, and her husband Hubert Bland. The red-brick mansion was built in 1733 for Sir Gregory Page, a beneficiary of the South Sea Bubble. Between 1779 and 1799 John Arnold, the famous clockmaker, lived there. Edith Nesbit and Hubert Bland, founder members of the Fabian Society, moved to Well Hall in 1899. In this decaying house they generously entertained their many literary friends. Hubert died in 1914 and in 1917, Edith married again, this time to Tommy Tucker, a captain of the Woolwich Ferry. The upkeep of the old house was a great burden and the income from Edith's chicken farm could not alleviate the problem. She and Tommy moved to Dymchurch in 1922. Well Hall House stood empty and was badly damaged by fire in 1926. Woolwich Borough Council bought the site in 1930, demolished the house and concentrated their resources on restoring the Tudor Barn. The site of the house is now part of Well Hall Pleasaunce gardens adjoining Well Hall Road.

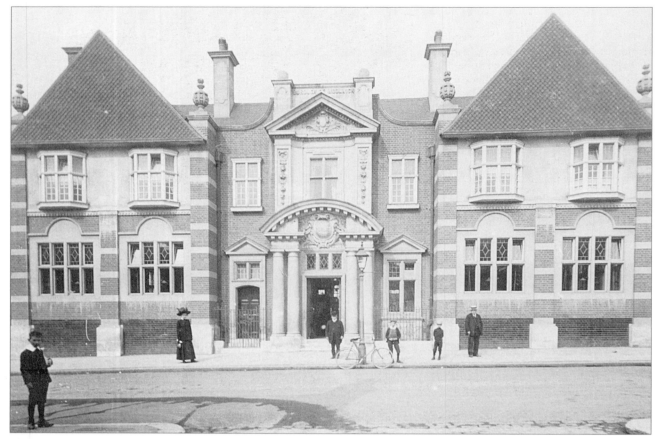

Eltham Library, *c.* 1908. Eltham Library, designed by Maurice Adams, was opened in 1906. It was just one of many fine buildings constructed in the first few years of the Metropolitan Borough of Woolwich. It has always been an extremely well used library because of its prominent position in Eltham's busy shopping area. As with East Greenwich Library and many other libraries built at that time a librarian's flat was provided.

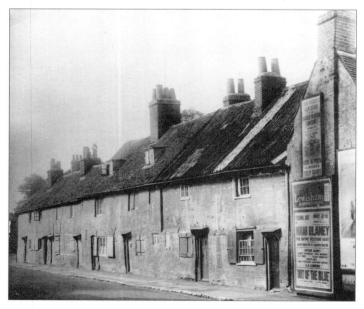

Pound Place, 1928. Happily, these old houses in Pound Place were recorded for posterity. The buildings may be old but petrol, cinema and tobacco advertisements leave us in no doubt that we are in the twentieth century. These buildings have been swept away, and deserted corners like this are rare in Eltham High Street.

Eltham House, Eltham High Street, *c.* 1930. At the beginning of the twentieth century four old houses with large gardens lined the north side of the High Street between St John's Church and Blackney's Smithy. As the High Street grew into a busy shopping centre all of these houses except Cliefden were demolished. The South Metropolitan Gas Company bought Eltham House, an attractive early eighteenth-century building, and used it as offices and showrooms. A period house like this would probably be in demand today for commercial use. However, in 1937, purpose-built showrooms for the display of new gas cookers, fires and water heaters were preferred. Thus, Eltham House was demolished and only its beautiful but derelict orangery survives today.

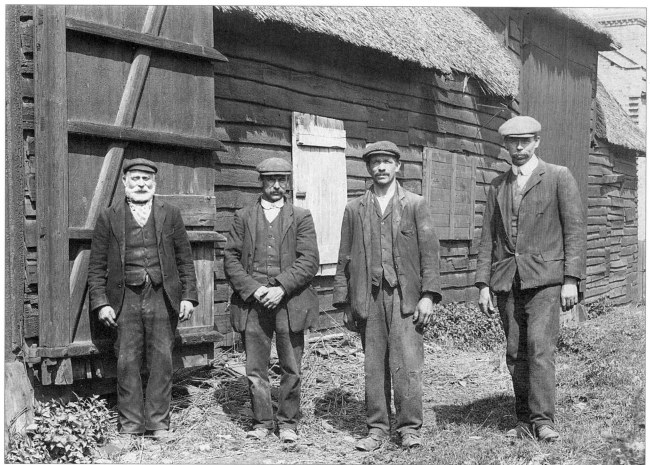

Farm workers, Manor Farm, Plumstead, 1908. These farm workers are standing in front of the tithe barn belonging to Manor Farm. Soon after this time the barn was demolished to allow for the building of 112–22 Benares Road.

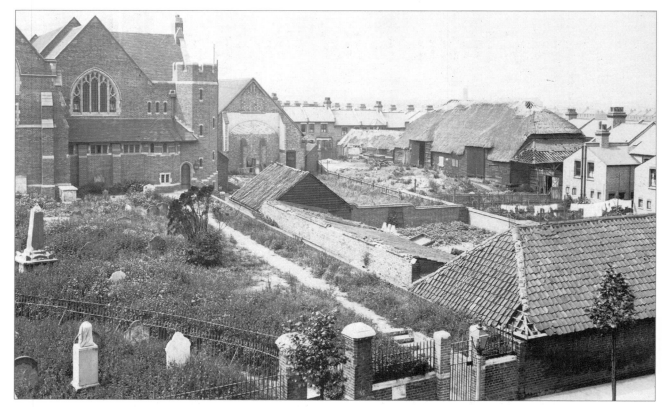

St Nicholas Church and the Manor tithe barn, Plumstead, 1908. The newly enlarged parish church and the last remnants of the once prosperous Manor Farm are seen here. The farmhouse which stood close to the church was demolished towards the end of the nineteenth century. The fields surrounding the farmhouse and the church were built over. The large and impressive tithe barn stood in Benares Road. However, soon after this photograph was taken it was demolished. Nos 112–22 Benares Road stand on the site today.

Bostall Farm, Abbey Wood, *c.* 1920. In 1938 Woolwich Borough Council had every intention of preserving this magnificent tithe barn which it had just acquired from the Royal Arsenal Co-operative Society. The seventeenth-century barn stood slightly to the south of McLeod Road and was completely surrounded by the Bostall Housing Estate, built between 1900 and 1914. Sadly, the barn was destroyed during the Second World War. Bostall Gardens now covers the site.

Industrial Thames

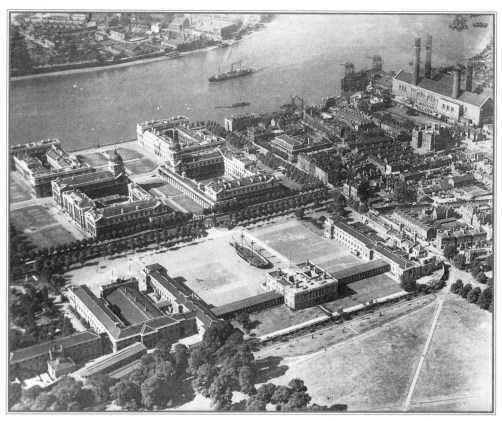

Greenwich Reach, *c.* 1930. The Royal Naval College and the Greenwich Hospital Schools, now the National Maritime Museum, are in complete contrast to everything else in this aerial photograph. East Greenwich with its mixture of old housing and river industry borders the institutions and Greenwich Park. Meridian School, built in 1888, soars above the crowded streets. Opposite it on the northern side of Old Woolwich Road is the garden attached to Trinity Hospital. This almshouse, founded in 1613, fronts the river with a main entrance on Trinity Hospital Wharf, now Highbridge. Dominating Trinity Hospital and the school is the 1906 Greenwich Power Station. A massive jetty for coal ships juts out from Anchor Iron Wharf. Sailing barges belonging to Donovans Barge Builders are moored at Highbridge Wharf. The foreshore behind Crane Street, a riverside pedestrian-only lane, is given over to boats belonging to Corbetts boatmen and the Curlew Rowing Club. On the Isle of Dogs are Island Gardens and Luralda Wharf.

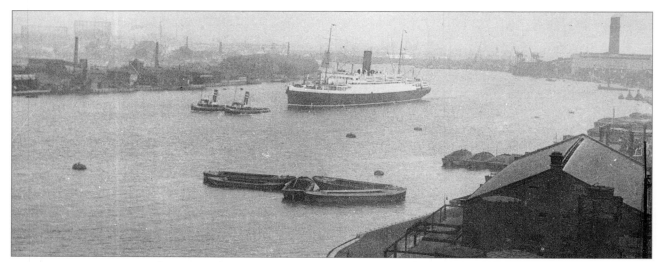

View from Deptford Power Station towards Greenwich Peninsula, 1924. Tugs tow a ship up-river to London's docks. The great bends in the Thames make it appear that the two large gasholders at the East Greenwich Gasworks on the Peninsula (now the site of the dome) are actually on the far side of the Isle of Dogs. Prominent on the right of the picture is Greenwich Power Station. This power station was built in 1906 by the LCC to provide power for the tramway system and, later, for the London Underground. It is shown here after two chimneys had been lowered at the request of the Astronomer Royal. Today, all four chimneys are the same height. The large coal jetty which supplied the station is no longer used but can still be seen today. The station is just one element in a predominantly industrial riverscape.

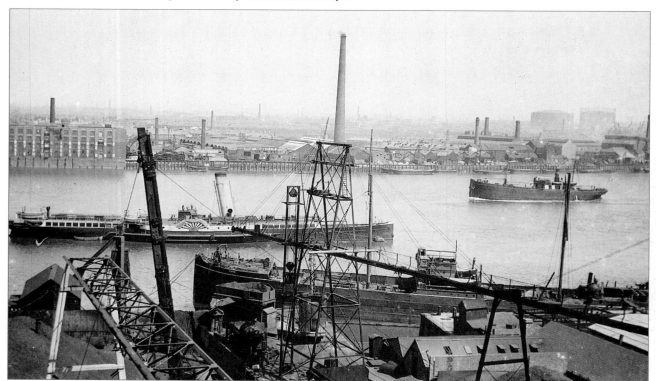

Pleasure steamer off Deptford, 1924. A Thames *Belle* passes Deptford on its way to Greenwich Pier. The *Belle* steamboats belonged to the London, Woolwich and Clacton-on-Sea Steamboat Co. Ltd. It was always difficult for steamboat companies to make excursions to the coast profitable and the *Belles* soon passed on to new owners, one of whom was the East Anglia Steamship Co. They regularly plied between London and coastal resorts until 1939 when surviving craft were requisitioned for war service.

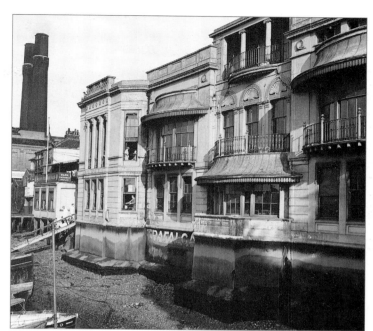

The riverside at Crane Street and Highbridge, Greenwich, 1938. The Trafalgar Tavern, designed in 1837 by Joseph Kay, is in the foreground here. Beyond it can be seen the Yacht Tavern, Corbett and Son boat builders, and Greenwich Power Station. The power station then supplied power to the London tramway system.

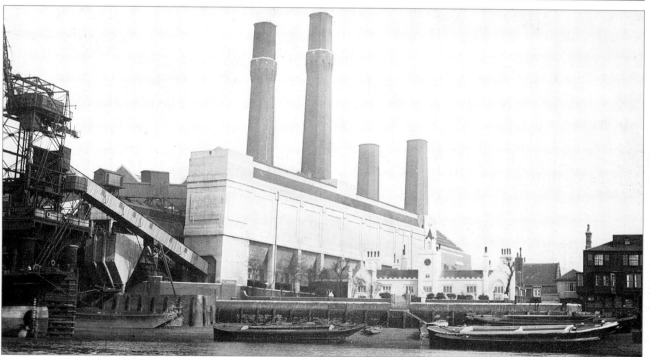

Highbridge and Trinity Hospital Wharf, c. 1935. This view from the river encompasses buildings from the seventeenth to the twentieth centuries. Trinity Hospital has been home to twenty-one retired men since 1614. Before the power station was built the almshouses did not stand alone: a Jacobean mansion, Crowley House, was soon built adjacent to them. In 1854 Crowley House was demolished and stables for the horse trams were built on the site. In 1906 these were in turn pulled down and Greenwich Power Station built. The Crown and Sceptre, standing to the west of Trinity Hospital, was a fashionable tavern throughout the eighteenth and nineteenth centuries. The Duke of Wellington dined there after the Battle of Waterloo, and Charles Dickens wrote to a friend from America enquiring 'Perhaps you dine at the Crown and Sceptre today, for it's Easter Monday.' This picturesque old tavern became the clubhouse of the Curlew Rowing Club in the twentieth century. It was demolished in 1936.

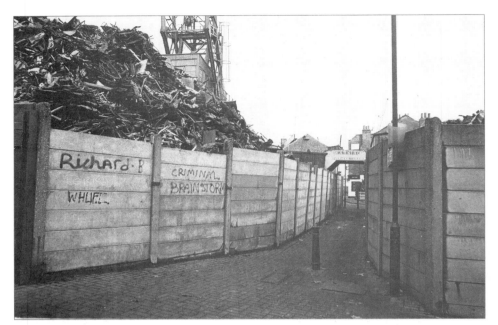

Robinson's Scrap Metal Works, Anchor Iron Wharf, 1980s. This is the riverside walk past Anchor Iron Wharf looking towards Ballast Quay. Robinson's Scrap Metal was set up in 1835 at the adjacent Crowley's Wharf, later moving to Anchor Iron Wharf. The firm passed out of family control in the 1960s and, by 1992, it had closed. Robinson's continued a tradition of metal handling started by Ambrose Crowley. Crowley, the great ironmaster, moved his main iron goods warehouse from the City of London to Greenwich in 1704.

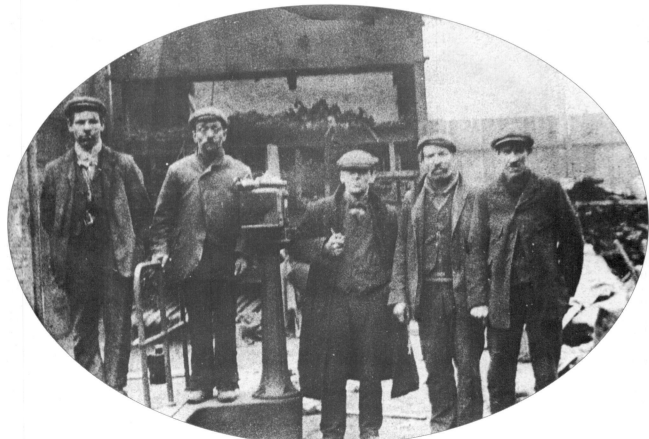

Robinson's Scrap Metal Works, Anchor Iron Wharf, c. 1910. Five of the workers at the yard pose for the camera with a weighing machine.

Ballast Quay, 1970s. A restful interlude on the riverside walk outside the Cutty Sark public house (formerly the Union Tavern). To the right is Lovells Wharf, which was then busy with coasters from Rotterdam and Antwerp. On the peninsula can be seen the silos of Tunnel Refineries and the twin gasholders of the East Greenwich Gasworks.

View from Charlton Wharf to Deptford and the Isle of Dogs, c. 1972. Tugs and lighters bring life to this scene on the River Thames in the second half of the twentieth century. Gasworks, power stations, warehouses and cranes are still in place. In the far distance the Royal Naval College, Deptford Power Station, and old parish churches form an historic backcloth. In the 1970s Thames industries and docklands were gradually disappearing. After 1980 the whole scene changed with factories, power stations and warehouses closing. River traffic dwindled and ship 'spotters' found less and less to interest them.

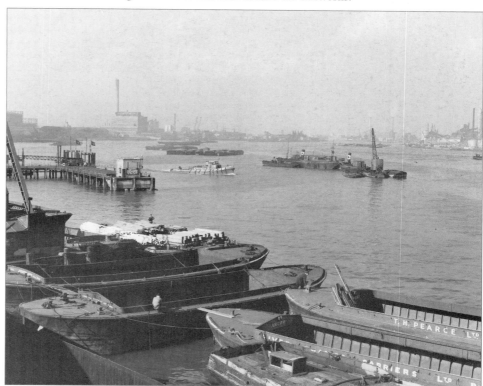

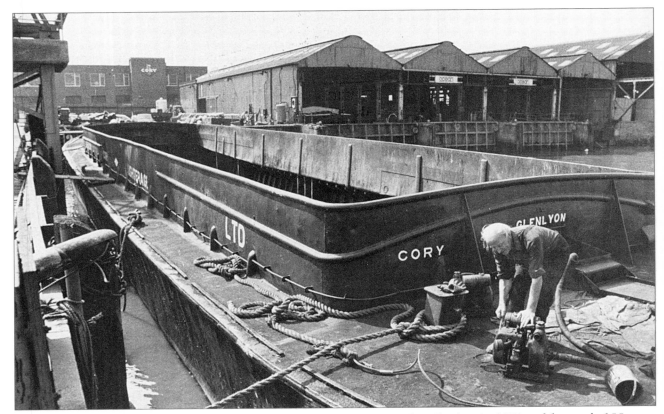

Cory's Barge Works, Charlton, *c.* 1965. William Cory established a barge yard at Charlton in 1873 and for nearly 100 years employed many journeymen and apprentices. Cory's distinctive black diamond symbol was a familiar sight on the Thames. As work moved away from the river so the need for Cory's barges and lighters diminished. In 1972 the Ocean Steam Ship Co. took over the business but kept the original name. The Charlton works were scaled down but a few barges were still being repaired there at the beginning of the 1990s. This work has now ceased but Cory's still have office premises at Riverside, Charlton.

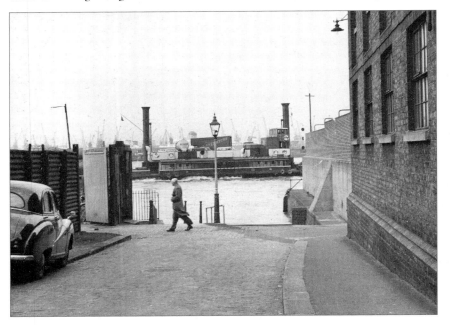

The Woolwich Free Ferry, seen from Bellwater gate. The romantic steam-powered paddle-boats were replaced by more efficient modern diesel ferries in 1963. The ferry service was the first free transport in England (set up in 1889 by the London County Council) and remains the only free service. On the left-hand side of the photograph today is the Waterfront Leisure Centre, and on the right a car park.

St Mary's Church and St Mary's Estate, c. 1970. This is the St Mary's area of Woolwich after it had been redeveloped between 1952 and 1961. The streets in this 62-acre plot in Woolwich were badly maintained and occupied by many poor families. On the left of the picture is St Mary Magdalene Church, built 1739 on the site of an earlier church, the ancient parish church of Woolwich. Close to it on the left is the round tower of Sunbury Street Fire Station. The eastern part of Woolwich is dominated by the tall chimneys of Woolwich Power Station (now demolished), and the tall block of Riverside House. Across the river the docks of North Woolwich can be clearly seen.

'Plumstead Against the River Crossing', group outside St Nicholas Church, c. 1980. The building of a bridge over the Thames between east London and south-east London was suggested in the 1930s but it was not until 1979 that the East London River Crossing became a planned part of the national trunk road programme. The road was to enter Plumstead at Tripcock Point on Thamesmead and then head towards the lower slopes of Shooters Hill. This section of the road would have blighted much of residential Plumstead and ruined the tranquillity of fields at Woodlands Farm on Shooters Hill. It would then have cut through Oxleas Wood, an ancient woodland, in order to join up with the Rochester Way Relief Road. The road was such a threat to the local community that a vigorous campaign was started against it. The actions of PARC were so successful that the road became a national issue. Public Inquiries were held in 1985–6 and 1989. All seemed to be lost when, in January 1990, a further draft compulsory order was issued. Media cover further increased and a number of residents and activists put their homes on the line to take the case to the European Court. Finally, people power triumphed and justice was done when the scheme was abandoned in July 1993.

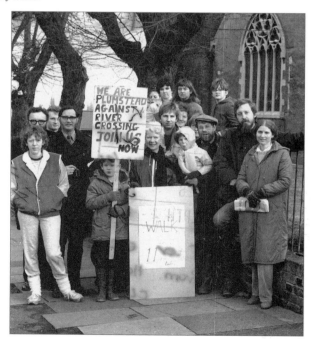

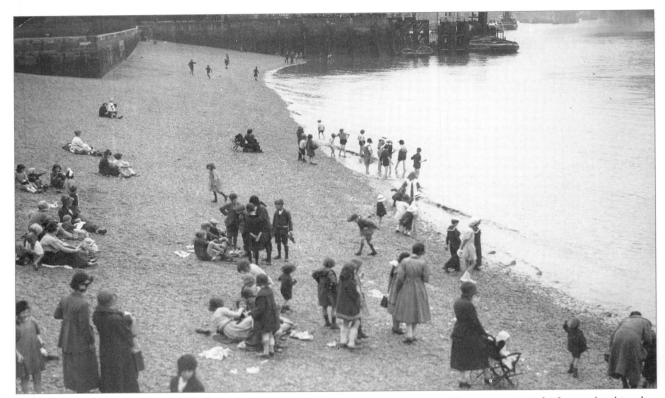

On the beach. Greenwich. *c.* 1930. These boys and girls with their mothers seem to have come straight from school to play on the sand at Greenwich and have a paddle. Two boys, gazing at the river, are wearing the uniform of the Royal Hospital School, which moved away from Greenwich in 1933. Beyond the pier, where a tall funnelled boat is moored. Greenwich Reach is full of ships and lighters.

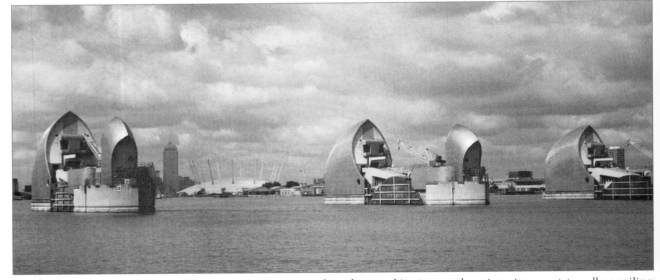

Twenty-first century riverscape. Three impressive pieces of modern architecture and engineering greet travellers sailing upstream. The Thames Barrier was built between 1974 and 1983 by the Greater London Council to save London from further disastrous floods. The Millennium Dome of 1999, looking a little like a giant pincushion, dominates Blackwall Point in East Greenwich. On the opposite side of the river is No. 1 Canada Square, Canary Wharf. This 800-ft high tower, finished in 1991, is clad in stainless steel and is seen at its best during sunset when it positively glows!

Engineering Excellence

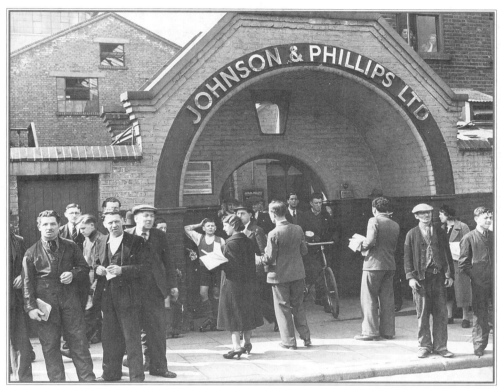

Apprentices' strike, Johnson & Phillips Ltd, Charlton, April 1939. In 1875 Claude Johnson and Samuel Phillips opened a small workshop on the western side of Victoria Way, Charlton. Within two years they had established a thriving telegraph cable works. The story of Johnson & Phillips was one of invention and expansion. Factory buildings spread to both sides of Victoria Way and, by 1930, there were regional sales offices throughout the country. In 1964 Delta Enfield Cables took over the works and, by 1969, almost all of the buildings north of the railway line had gone. Delta Enfield Cables finally closed in 1990.

In early 1939 there was a nationwide call for engineering apprentices to be paid more. About 250 'lads' went on strike at Johnson & Phillips under the slogan of '3 shillings or else'. Almost immediately other south-east London factories were affected. The major strike was at Siemens factory in Charlton where 8,000 workers walked out led by Charles Wellard, a shop steward, because the management sacked an apprentice. By the end of April all the strikes were over. They had the effect of causing managements to examine their wage structure.

Open day at Siemens Brothers' Woolwich works, early 1960s. Visitors to the factory are greeted at the Yately Gate in the Woolwich Road. Siemens built their first factory on the riverside on the Woolwich/Charlton boundary in 1863. By 1958 this famous cable and electrical works covered all the land from the Thames to the Woolwich Road on a site bounded by Hardens Manorway and Warspite Road. Badly bombed during the Second World War the factory was repaired and rebuilt after 1945. However, after a series of takeovers the whole plant was closed in 1968, resulting in the loss of thousands of jobs. The abrupt closure of Siemens was the forerunner of many such factory closures. There are a few surviving buildings dating from 1871–99 on the Westminster Industrial Estate, which occupies the former Siemens site.

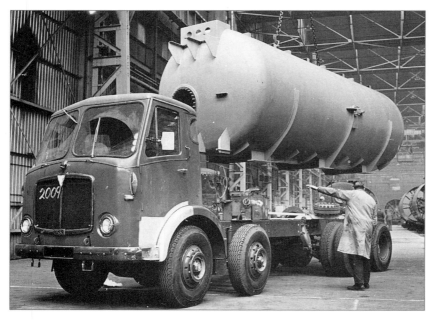

G.A. Harvey Ltd, Woolwich Road, Charlton. George Drinkwater, foreman slinger, helps a crane driver to load a butane tank on to a transporter. It was not unusual to hear a warning about a 'heavy load' leaving Harvey's works in Charlton. The factory was built on land near Horn Lane. All types of metal goods including steel office furniture were manufactured at the plant. Steel plates for landing craft and pieces of Mulberry harbour left Harvey's works in 1944 for the D-Day landings. By 1969 the firm was in decline and a merger with Butterfield of Yorkshire did not save it. The factory closed in the 1980s and Holmwood Villas and other developments were built on the site.

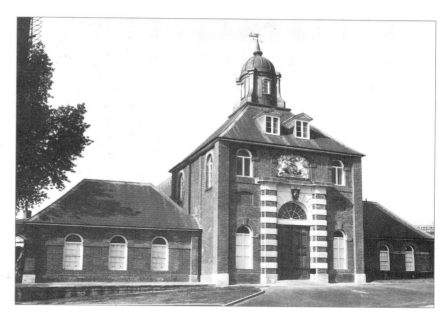

The Royal Arsenal, Royal Brass Foundry, Woolwich 1696–1967. The main block of the foundry was first built in 1717 and is attributed to Sir John Vanbrugh. It is a fine and rare example of a very early Industrial Revolution building. The keystone of the arch bears the Arms of the Duke of Marlborough, 1717. Above the keystone is the Royal Arms. Used for the founding of brass cannon, guns were cast in the building until *c.* 1870. The Royal Brass Foundry was restored in the 1970s and at the moment is used as a store by the National Maritime Museum.

The Royal Arsenal Officers' Mess. Built in 1720 as an administrative building for the Board of Ordnance, it became the Royal Military Academy in 1741. In 1806 the Academy moved to Woolwich Common and this building became the Royal Laboratory model room. Its last use was as the officers' mess. The Lion and Unicorn on the porch were on the gateway to the Royal Laboratory. Above the clock is a wind vane by Bennett, the famous clockmakers of Greenwich and Blackheath. It is planned that this building will form part of the Royal Artillery Museum.

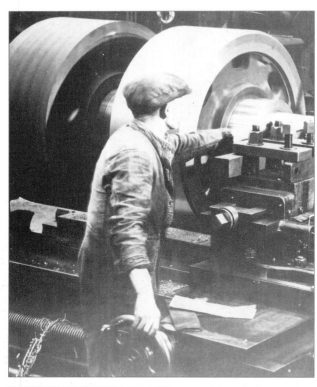

The Royal Arsenal, Woolwich. Engineers at work in the Royal Ordnance Factory. It closed in 1967.

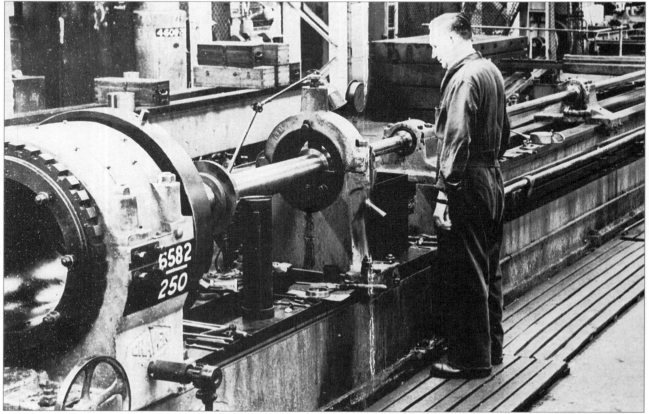

The Royal Arsenal, Woolwich – entrance to Dial Square. Built as the 'Great Pile' between 1717 and 1720 it was renamed Dial Square when the sundial was placed on the arch in 1764. At one time Dial Square was a workshop for boring and machining guns, which had been cast in the nearby Royal Brass Foundry. In 1886 the Dial Square Football Club was formed. The name was quickly changed to the Royal Arsenal Football Club, and then, in 1891, to Woolwich Arsenal Football Club. After the club moved to Highbury in 1913 it was renamed Arsenal Football Club but its nickname 'The Gunners' maintains the link with its origins in Woolwich.

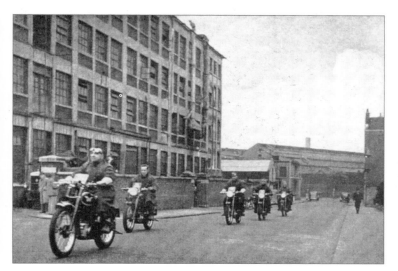

AJS Motorcycles, Maxey Road, Plumstead, c. 1936. Testing motorcycles on the streets of Plumstead. This factory, on the corner of Maxey Road and Burrage Grove, was one of the largest motorcycle factories in the country. In 1899 the production of Matchless motorbikes started there. By 1937 the name had been changed from AJS to Associated Motorcycles. In 1963 Norton's took over the factory but six years later the business closed and the buildings were demolished.

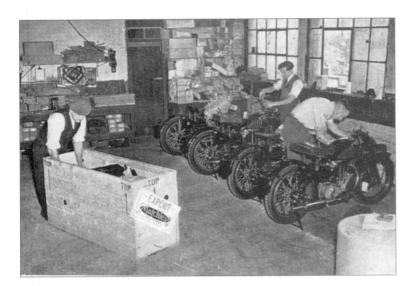

AJS Motorcycles, Plumstead, *c.* 1936.
Motorcycles are being packed for export to
foreign markets. Seventy-five per cent of the
factory's output was exported.

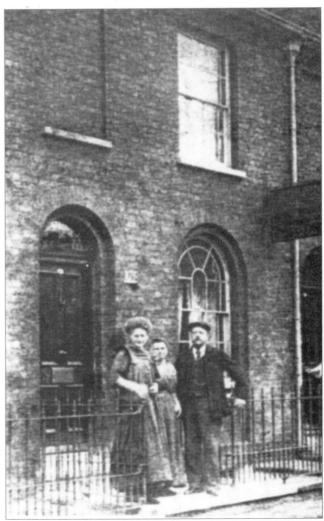

Turner and Gripton Wire Works, Trafalgar Grove,
Greenwich, *c.* 1910. William and Jeanette Turner are
standing outside 16 Trafalgar Grove. William was in
partnership with his next-door neighbour, T. Gripton, a
blacksmith by training. The taller of the two women is Ivy
Turner (later Ivy King). Only three of the original houses
in Trafalgar Grove remain.

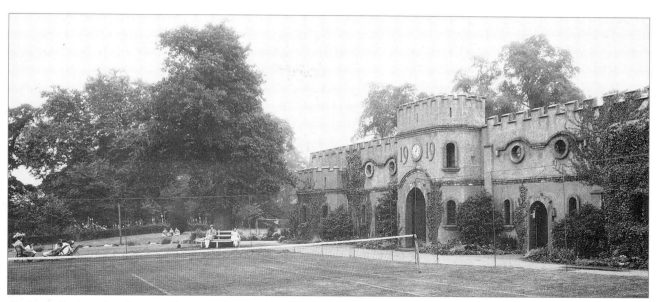

Grafton's Engineering Factory, Footscray Road, Eltham, 1920s. In 1919 Walter Grafton moved his engineering works to Footscray Road. In order to blend in with the rural surroundings he agreed to build a factory that looked more like a small country house than an industrial building. The tennis courts at the front of the building further underlined the graceful image. In 1988 it was demolished and a B&Q store stands on the site.

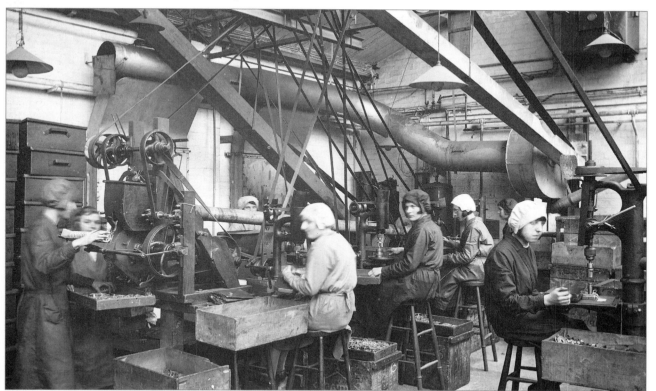

Women workers at Grafton's Engineering Factory, Footscray Road, Eltham, 1920s. Grafton's employed about 350 men and women. Their main products were spools for typewriter ribbons, adding machines and cash registers. Here each woman has a box of spools beside her. The factory also produced zip fasteners, electric light arms, and radio valve pins. The photographs on this page were kindly donated by Barry Saunders, whose father was manager of the works.

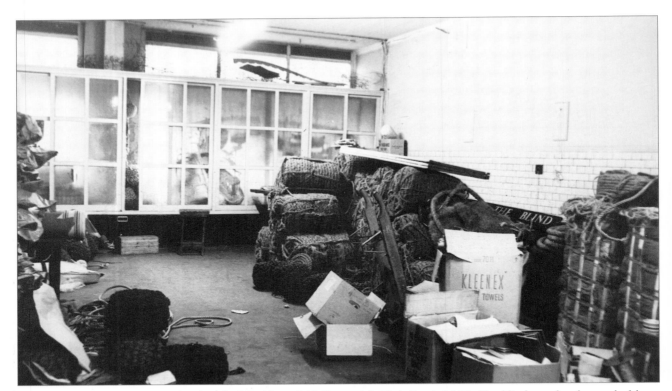

An interior of the Workshops for the Blind building, 166 Greenwich High Road, 1972. The blind people who worked here made a range of goods including fend-offs for boats, and doormats. The workshops, which had been established in 1877, were closed by Greenwich Council because the number of workers had dwindled, and young people were not interested in these traditional crafts. However, the existing workers were unhappy at the closure because they were used to the work, and they could find their way there from home with ease. The council saw the opening of a new Remploy factory in Kidbrooke as offering greater opportunities than the workshops. The building was demolished but parts of the stonework were incorporated in the redevelopment close to the site. Another workshop in the old East Street Mission in Eastney Street, now Feathers Place, was also closed.

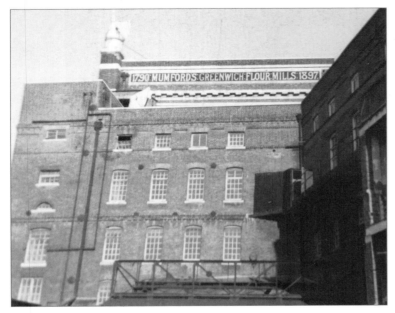

Mumford's Flour Mills, 23 Greenwich High Road. This building is a 'left-over' from the grain-milling centre of Deptford and Greenwich, originally drawing its power from the adjacent River Ravensbourne. The Mumford family established the business in 1794. In the 1950s, equipped with the latest machinery, Mumford's was renowned for quality flour called 'Greenwich Meridian'. The building, facing Deptford Creek, was designed in 1897 by Aston Webb. In the second half of this century the business was taken over by Rank Hovis McDougall. They closed the plant in 1963. Permission is being sought to convert the mill into housing.

Growing Up

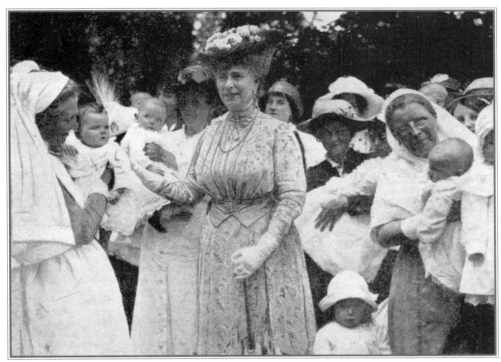

Queen Mary in the garden of the Home for Mothers and Babies, Woolwich, 6 June 1917. Sister Alice Gregory founded Woolwich's first public maternity home at 65 Wood Street (now Woodhill) in 1905. The home became famous for the standard of care for both mothers and babies. Queen Mary, wife of George V, visited the wards in the three-storey house and met eight pupil-midwives. She then went to the garden where fifty or more babies, all born in the home, were assembled. Alice Gregory, wearing spectacles, is standing on the queen's left holding one of the babies. She also visited the site in Samuel Street, which was being prepared for the building of the British Hospital for Mothers and Babies. Queen Mary returned in March 1922 to open the new hospital for the redoubtable Alice Gregory, who worked there for another twenty-three years. She was rightly renowned for her forty years as Woolwich's first lady of midwifery. In 1984 Alice's hospital was closed, emptied and demolished.

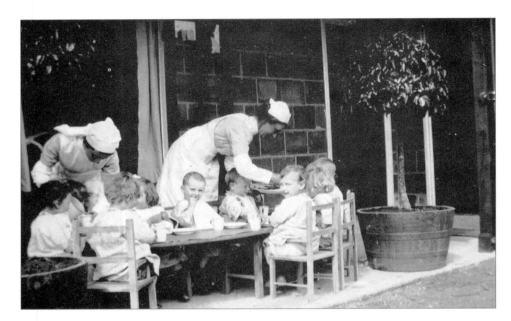

Open Air Nursery, Woolwich, *c*. 1917. Dinner time at a nursery school for children of women munition workers. Margaret McMillan, pioneer of nursery schools, advised the authorities and insisted that trained nursery teachers be employed where possible.

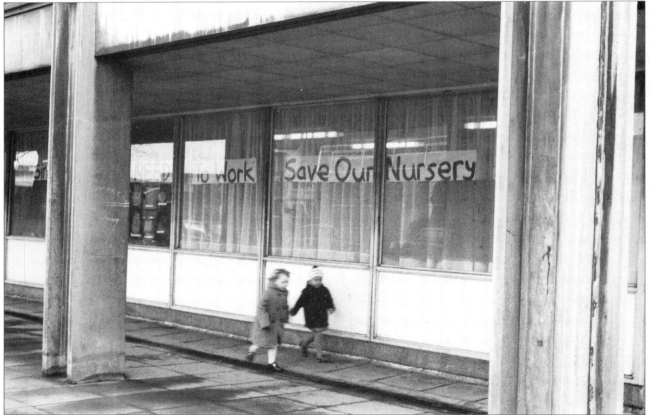

Vanbrugh Day Nursery, Greenwich District Hospital, 1982. This nursery, housed in the hospital, was opened in 1972. Seventeen places were reserved for the children of hospital staff and priority was given to single-parent families. In 1981 Greenwich and Bexley Health Authority withdrew their funding and, by 1982, the nursery was threatened with closure. The day nursery opened from 7.30 a.m. until 5.30 p.m., and took children until they were five years old. A campaign to save the nursery failed and it was closed.

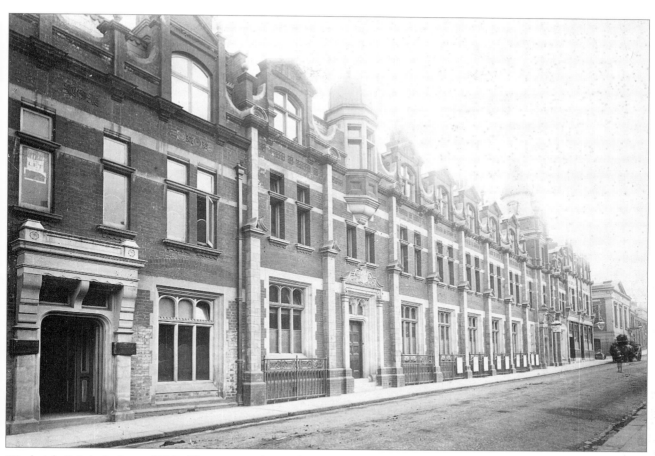

Woolwich Polytechnic, *c.* 1910. The picture shows the original building of Woolwich Polytechnic, now Greenwich University, in Calderwood Street. A Woolwich architect, Henry Hudson Church, who also designed Woolwich Baths (1894) and Woolwich Library (1901), built it in 1891, one year after the Polytechnic's foundation. Woolwich was the second polytechnic to be established in London. In the background on the corner of Polytechnic Street is the Old Town Hall built by the Woolwich Commissioners in 1842. It was used as a town hall until the new one in Wellington Street opened in 1906.

Closure of the Royal Hospital School, 1933. The Royal Hospital School came to Greenwich in 1806 and was accommodated in the Queen's House. Extensions linked by colonnades were added and the school was renamed the Royal Hospital School in 1821. Thousands of boys were trained for the Royal Navy at Greenwich until the school moved to Holbrook in Suffolk in 1933. Between 1933 and 1937 the empty buildings and the Queen's House were refurbished to accommodate the National Maritime Museum.

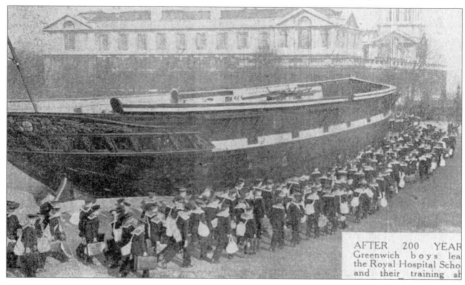

AFTER 200 YEAR
Greenwich boys lea
the Royal Hospital Scho
and their training sh

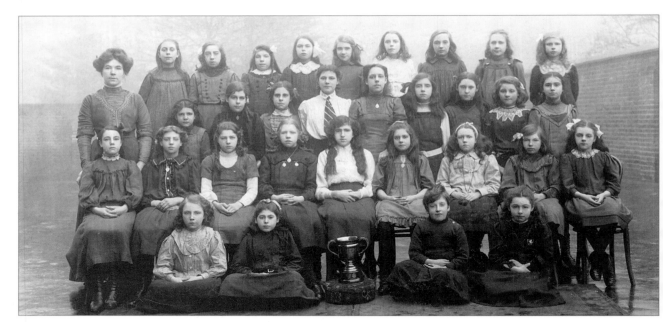

Champion swimmers, Royal Hill School, Greenwich, 1911. The only public baths and washhouses in Greenwich at this time were at the foot of Royal Hill. Meridian House, the former Town Hall of the Metropolitan Borough of Greenwich, stands on the site today. It was there at the 'Greenwich Baths and Wash-houses for the labouring classes' that our champion swimmers must have competed. Royal Hill School was built in 1898. Part of the school became Greenwich Park Central School for Girls and, after 1947, the whole of it became Greenwich Park Secondary School for Girls. The school was closed in 1985 and the buildings are now used for adult education.

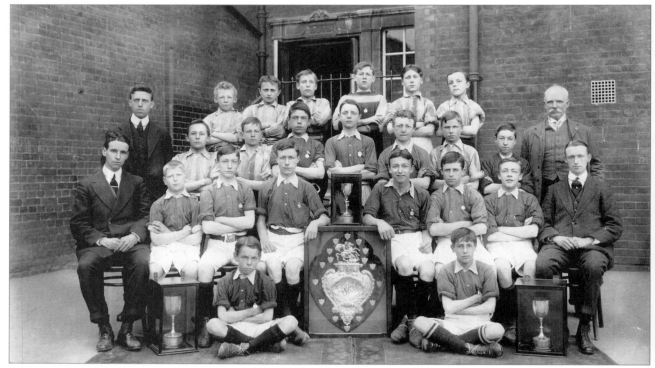

Ancona Road School, Plumstead. These fit young men were winners of the Woolwich Senior Football Competition, 1911/12, and Sports Champions, 1911. The school stood on the corner of Ancona and Heavitree Roads.

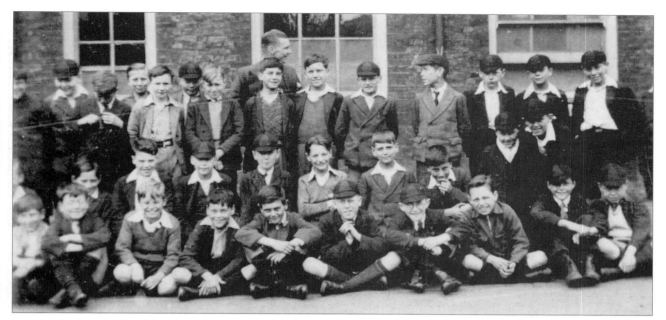

Greenwich Central School for Boys, Catherine Grove. Greenwich, 1934. This happy group is gathered in the playground at the end of the summer term. Unlike most school photographs this group is very relaxed and informal – some of the boys and the teacher are not even looking at the camera! No doubt end of year happiness has overwhelmed most of them. Sitting on the ground in the front row, fourth from the left, is Alfred Bird of Greenwich.

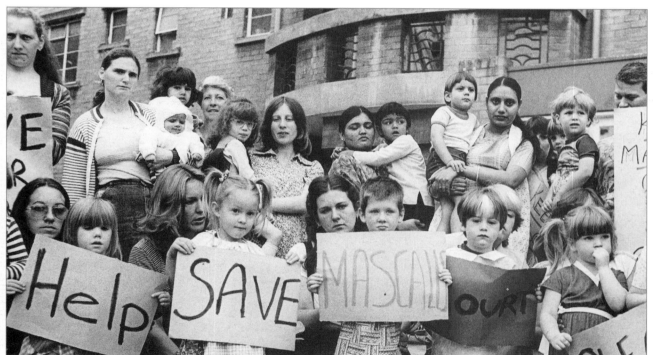

'Save Our Playgroup'. Mascalls Court. Charlton. September 1981. Parents and children demonstrated in an effort to save the estate's playgroup in Victoria Way. More than 170 tenants signed a petition protesting against the proposed closure. The demonstrators were extremely disappointed when they failed to prevent it. A spokesperson for Greenwich Council said, 'According to records the playgroup is underused.' Parents disagreed, pointing out that there was a long waiting list of children wishing to join.

Crown Woods School, Eltham. Crown Woods was one of London's earliest comprehensive schools. It was a school of unprecedented size, being designed for over 2,000 pupils. It opened in 1958, four years after Kidbrooke Comprehensive School (now Kidbrooke School) which was the first purpose-built comprehensive in London.

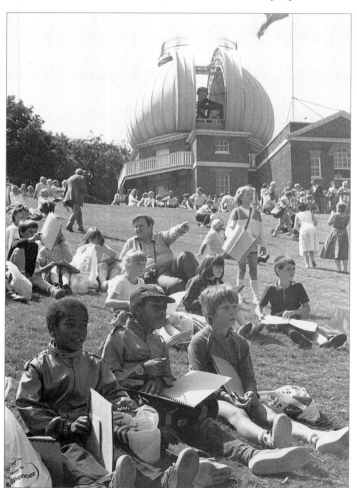

Observatory Hill, Greenwich Park, 1975. Sitting beneath the onion cupola of the Great Equatorial Building of the Old Royal Observatory the teacher and his school party have plenty of things to look at: the National Maritime Museum, the Queen's House and the Royal Naval College are just a few. Across the river the docks are on the point of closure. It would be another fifteen years before the controversial tower of no. 1 Canada Square at Canary Wharf would rise to dominate the view from Observatory Hill.

Getting About

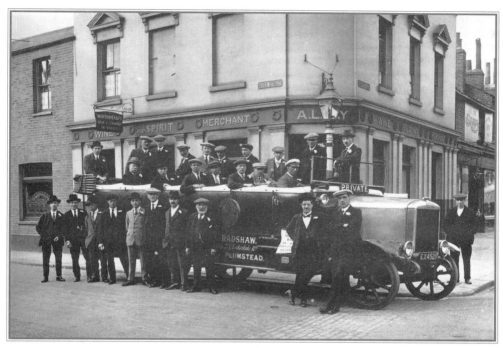

A charabanc outing from the Royal Albert public house, Woolwich, *c.* 1925. Jaunts like this were often called 'beanos'. This slang word derived from 'beanfeast', a name for the annual dinner given by employers for their workers. Undoubtedly, this charabanc would have been well stocked with enough sustaining liquor to keep the sing-song going there and back. This vehicle was hired from Albert Bradshaw of Lakedale Road, Plumstead, who also had a flourishing fruiterer's and greengrocer's shop at 23 Lakedale Road. The Royal Albert stood on the corner of Kidd Street and Prospect Row. The shops were in Prospect Row. This area has been redeveloped and Hawkins Court in Prospect Vale now stands on the site of the pub.

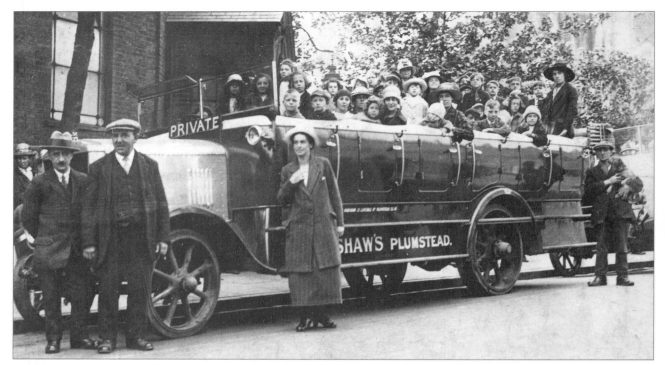

Cage Lane (now Lakedale Road) Mission Sunday School outing, Plumstead, 1923. This is a traditional charabanc outing with excited children in their Sunday best off to some exotic location. Much of the excitement of these outings must have been the journey there and back. As with the Prince Albert public house outing charabancs travelled extremely slowly, leaving little time to explore the delights of the destination.

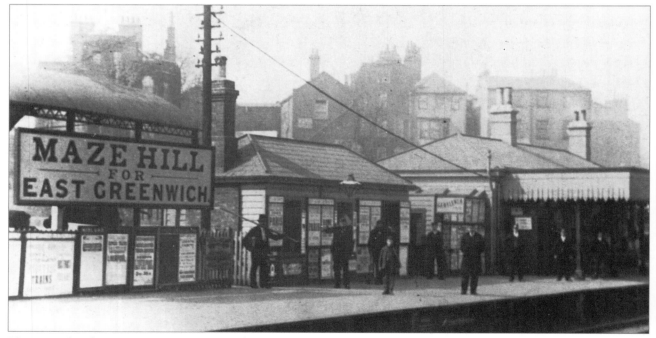

The original and picturesque Maze Hill station (down platform), Greenwich, on the Greenwich–Woolwich line, *c.* 1900. This part of the line, completed in 1878, was an extension of the original London–Greenwich line, which opened to Deptford from London Bridge in 1836, and to Greenwich in 1838.

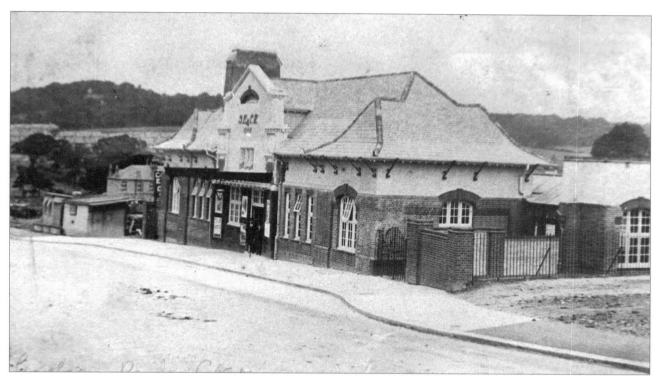

Eltham Park station, *c.* 1908. This station, originally Shooters Hill and Eltham Park, was designed by the famous practice of Sir Arthur Blomfield and Son, church designers. The Shooters Hill element was dropped from the name in 1927. The station, along with Eltham Well Hall, closed in 1985 to be replaced by the new Eltham station.

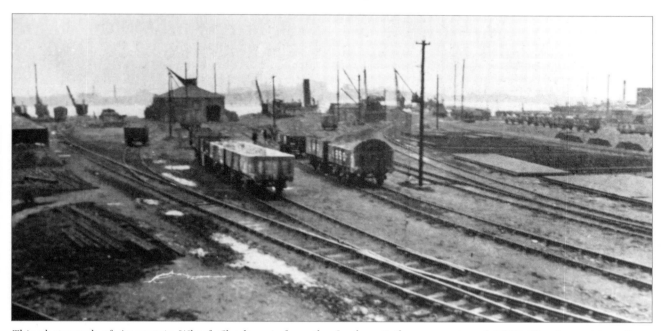

This photograph of Angerstein Wharf, Charlton, is from the *Southern Railway* magazine of 1925. The Angerstein railway line and wharf were the result of an investment by John Angerstein of Woodlands in Blackheath. Opened in 1852 the line joined the main Greenwich–Woolwich railway line west of Charlton station. In order to cross the Woolwich Road on a bridge Angerstein had to obtain a unique private Act of Parliament. The wharf and line are still in operation.

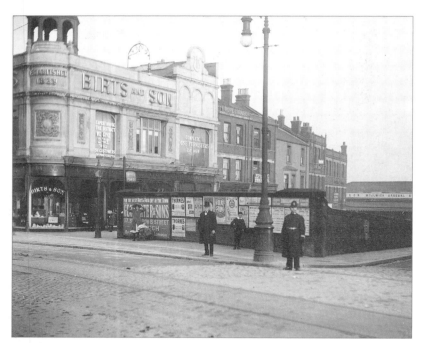

'The Smokehole', Woolwich, *c*. 1920. The Smokehole was a long-standing source of anger for traders whose shops were sited on either side. This large cutting was a ventilator for the steam trains entering and leaving Woolwich Arsenal station. Thomas Brown, a tailor of Hope House, 3 Russell Place (the north side of the square), organised a campaign along with his fellow traders who were also fed up with their goods and shops being coated with soot from the open cutting. Mr Brown made a model and drew a picture of how he thought the new square ought to look and got up a petition of 20,000 signatures. The opportunity to get rid of the Smokehole came when the railway line was electrified in 1926. Thomas Brown's vision of a glorious square with a statue of General Gordon was not realised. However, the area was renamed General Gordon Square, and the hole was filled in. The square is now Woolwich's main bus terminus.

View across Stockwell Street and Greenwich High Road towards Deptford, *c*. 1965. The single-storey building in the foreground was originally Greenwich Park station. Opened in 1888 the Greenwich Park line from Nunhead to Greenwich via Lewisham Road and Blackheath Hill stations was a commercial disaster. It closed in 1917, never to reopen. The platforms of Greenwich Park station were demolished and the railway cutting filled in. The station became a sawmill and was finally demolished in the 1960s along with other buildings on the corner of Stockwell Street and Greenwich High Road. The Ibis Hotel and Greenwich cinema cover most of the site today.

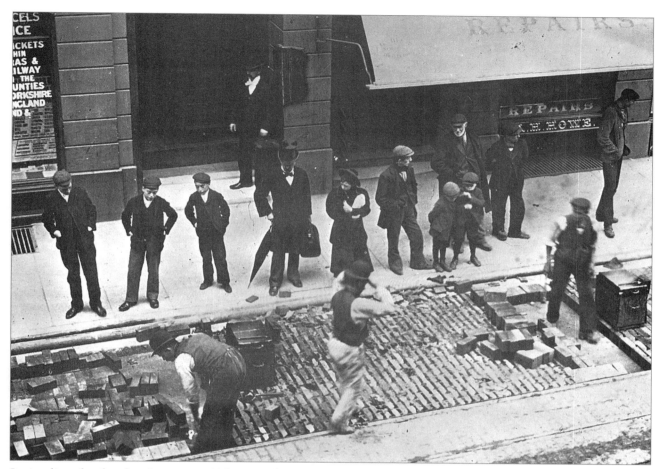

Laying lines for the electric trams in Nelson Road, Greenwich, 1903. The new electric service, which opened in 1904, replaced the earlier, slower horse tram service, which had operated since 1871. On the left of the picture can be seen the signboard of the Midland Railway Company booking office. On the right at no. 6 is the shop of Alfred Howe, umbrella maker, and at no. 5 Bickley's buoyant clothing syndicate.

Tram in Greenwich, 1951. A fine photograph by O.J. Morris of a no. 70 tram in Greenwich Church Street close to the junction with Nelson Road. This dates from the year before London trams were taken out of service.

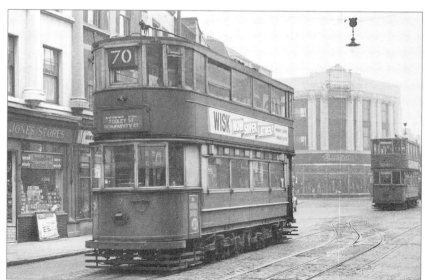

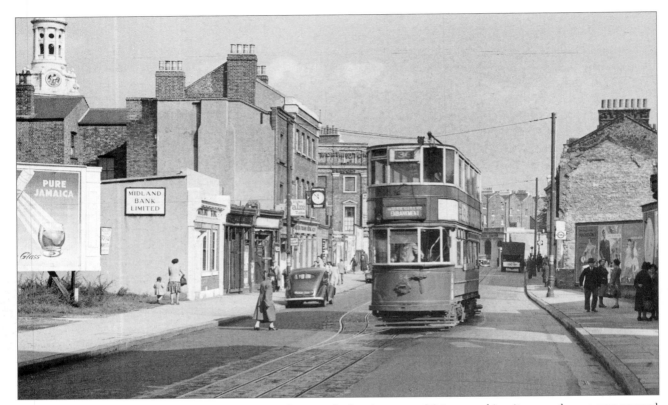

Greenwich High Road, 1951. Another O.J. Morris photograph showing a no. 36 tram making its way along a war-scarred Greenwich High Road. On the left the tower of St Alfege's Church can be seen and also part of the Mitre Tavern, a fine pub built in 1831.

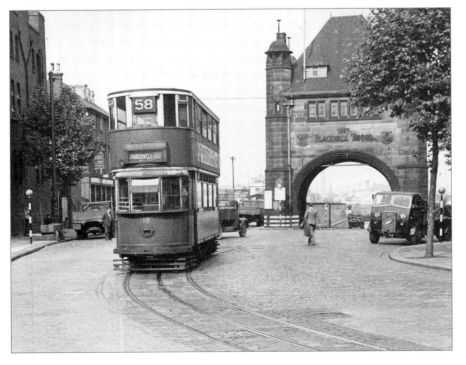

Tram at Blackwall Tunnel, 1951. A photograph by O.J. Morris of a no. 58 tram at its terminus by the gatehouse of the Blackwall Tunnel. The Blackwall Tunnel, built in 1897, was the first of three tunnels built by the LCC across the Thames in Greenwich: the others were the Greenwich Foot Tunnel in 1902 and the Woolwich Foot Tunnel in 1912. It is difficult to imagine now but up to the Second World War and beyond many pedestrians walked through the Blackwall Tunnel on the footways. The level of traffic today and the fumes would make walking a most unpleasant experience even if it was allowed.

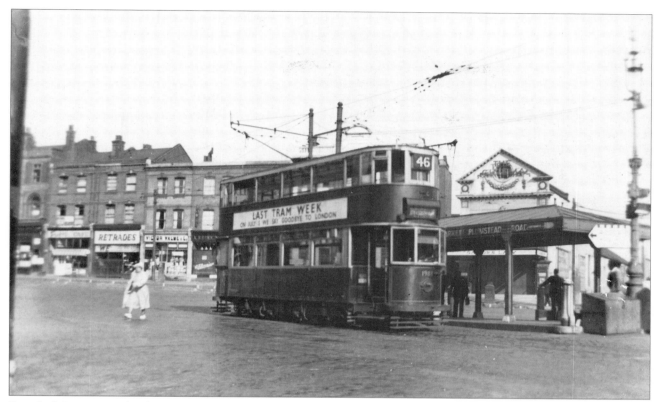

Beresford Square, Woolwich, 1952. A no. 46 tram at the island tram stop in Beresford Square. This was the last year of the trams in London.

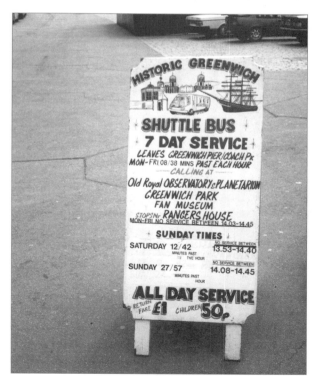

Shuttle bus service. This service was set up in 1994 by Owen Boyle to help visitors to Greenwich who might be daunted by the walk and steep hill to the Observatory and Rangers House.

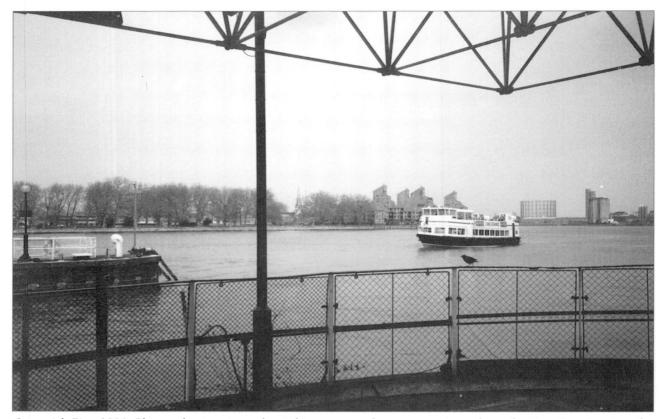

Greenwich Pier, 1996. Pleasure boats not merchant ships are now the commonest vessels on the river. Prominent on the peninsula are the tall silos, part of Tunnel Refineries, the glucose manufacturers, and the gasholder of the former East Greenwich Gasworks.

'Five foot walk', Riverside, Greenwich, *c.* 1970. When a new embankment to the Thames was made in 1731 as part of the design of the new Royal Hospital for Seamen (later the Royal Naval College), a riverside path was opened for the public. Starting at Greenwich Pier it goes as far as the Trafalgar Tavern. The back wall of Greenwich Pier made a handy message board for an unknown writer with a criticism of the controller of the pier. There was no harbourmaster but so what! Now such a message would be cleaned away by the council's award-winning graffiti removal squad.

Something Old, Something New:
Buildings before 1939

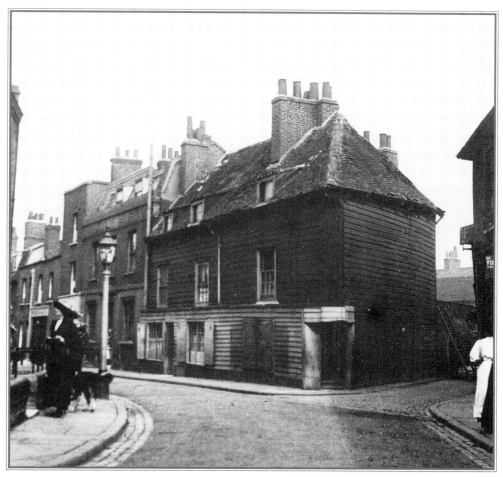

Eastney Street, Greenwich, *c.* 1905. An Edwardian view of one of the oldest streets in Greenwich. Eastney Street, formerly East Lane, stretched from Park Vista to the Thames and contained many early and interesting buildings. This photograph, originally a magic lantern slide, was taken at the corner of Eastney Street and the entrance to Crown Court. By 1938 the eastern side of the street, below Old Woolwich Road plus the buildings behind it, had been demolished to make way for the Ernest Dence Estate built by the London County Council. Aylmer House and Gifford House stand on the site of these buildings.

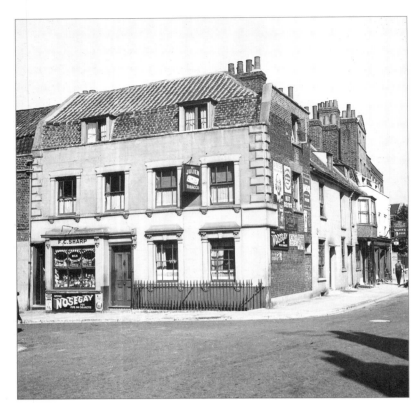

Corner of Park Vista and Feathers Place (formerly Eastney Street), Greenwich, 1937. The address of this shop in 1937 was 2 Eastney Street. Built as a house in about 1745 it was altered in the nineteenth century to allow for a shop on the ground floor. It remained a confectioner's shop until the latter part of this century when the whole building became a house again. The three small houses between the shop and the Plume of Feathers public house in Park Vista have gone but the pub, built in the eighteenth century as an integral part of the terrace, still flourishes.

Park Row, Greenwich, c. 1937. These old buildings stood between Trafalgar Road and Old Woolwich Road. They were originally the homes of naval officers attached to the Royal Hospital for Seamen (now the Old Royal Naval College) which stands opposite. The corner house became a tobacconist's shop, and the house next to that became the Greenwich School Treatment Centre. At the far end of the street, but on the opposite side of Trafalgar Road, is East Greenwich Police Station. The houses and the police station were demolished following serious bomb damage during the Second World War. There is now a car park on the site of these houses.

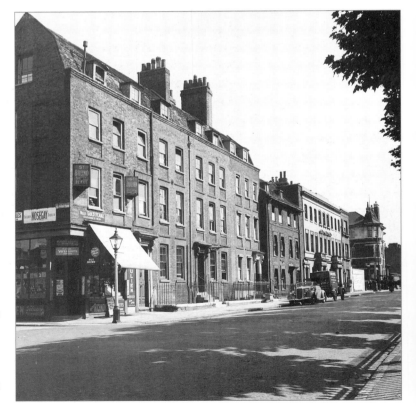

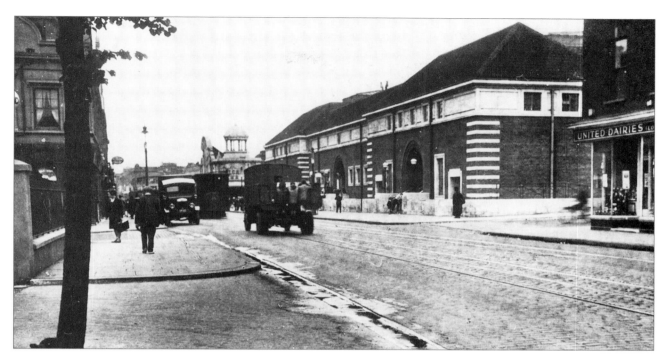

Trafalgar Road, Greenwich, *c.* 1930. Prominent in this view looking east along Trafalgar Road is the newly built Greenwich Baths. Opened in 1928 the baths offered excellent swimming facilities as well as slipper baths for those who hadn't the luxury of baths in their homes. The baths were radically redesigned in 1988 and reopened as The Arches, a modern leisure centre. Beyond the baths is the Trafalgar cinema, which became an Odeon in 1946 and closed in 1960 with *Carry on Constable*.

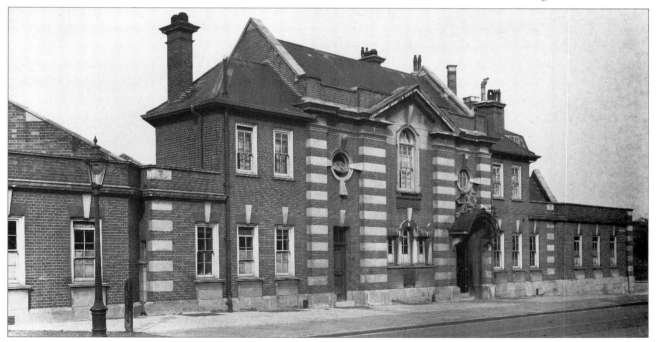

East Greenwich Library, Woolwich Road, soon after it was built, 1905. The Carnegie Trust provided the money to build this fine library with a flat for the librarian above. It became the Central Library of the Metropolitan Borough of Greenwich. East Greenwich Library is no longer the Central Library and now shares the building with Greenwich Community College. The tram-lines have, of course, long since gone and heavy traffic now thunders incessantly past.

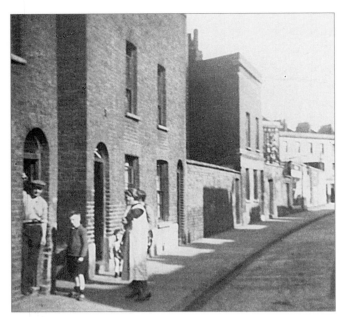

Nos 2–6, Billingsgate Street, Greenwich, *c.* 1935. These houses were on the east side of one of Greenwich's oldest riverside streets. By the mid-1930s they were due for demolition, as were the houses on the western side. The whole area was badly damaged when a flying bomb (V1) hit Beverley Mansions in 1944. The mansions stood between Greenwich Church Street and these houses. The west side of Billingsgate Street was redeveloped as Rockfield House and all the old buildings opposite were cleared away by 1953 for the making of Cutty Sark Gardens. The entrance to the 1902 Greenwich Foot Tunnel is close to this site and *Gipsy Moth IV* is berthed alongside Billingsgate Dock.

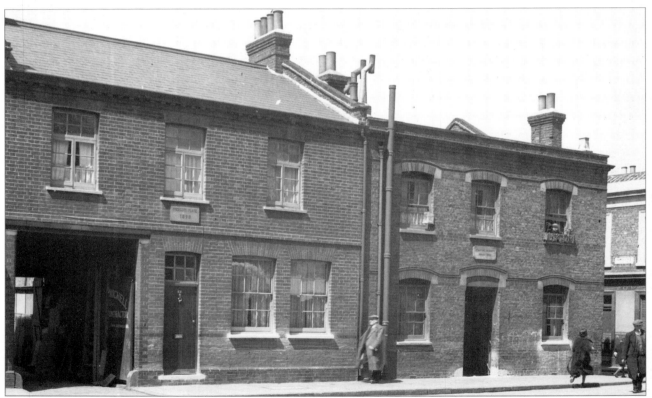

Nos 59–63 Greenwich Church Street, *c.* 1936. These houses, on the corner of Greenwich Church Street and Thames Street, were rebuilt in 1898 on land belonging to Stanton's Charity, founded in 1610. The charity made payments to the poor people of Greenwich and a contribution to Queen Elizabeth's Almshouses from renting out these houses. Prescott Place, no. 59, was built at the same time and, in 1936, was occupied by Harry Michell, a builder. During the late 1930s many old roads and buildings in the Thames Street area were demolished but these houses survived until 1976. By this time they had become derelict and were demolished.

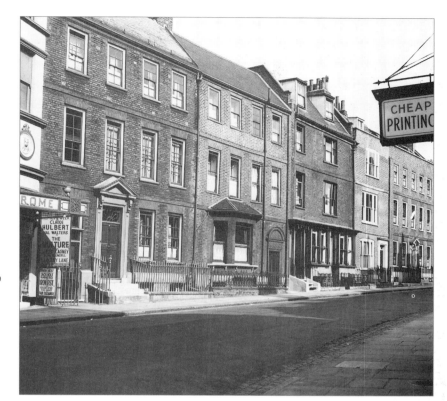

Nos 3–11 Crooms Hill, Greenwich, 1937. Films starring Claude Hulbert and James Cagney are featured on the poster outside the Hippodrome, now Greenwich Theatre, in Crooms Hill. Adjoining the picture palace is a terrace of houses built in 1706. Over the years alterations have been made, especially to the three houses in the middle of the group. Crooms Hill contains fine examples of domestic architecture from the seventeenth to the nineteenth centuries. 'Cheap printing' could be had at Tharp and Co., 4 Crooms Hill. This building was damaged by a V2 rocket and was subsequently demolished.

St Alfege's Hospital and Walnut Tree Walk, 1963. A few years later the old hospital was pulled down to make way for Greenwich District Hospital designed by Howard Goodman in 1970. St Alfege's Hospital was originally the Greenwich and Deptford Union Workhouse, built in 1840. The harsh regime in the workhouse was reflected in its grim design, which was obviously intended to deter local people from having to enter its fortress-like walls.

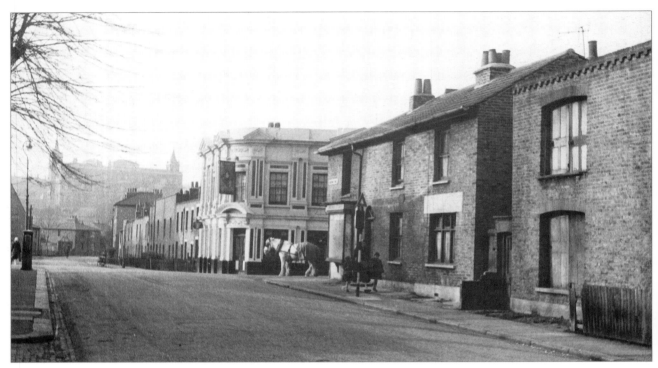

Kingsman Street, Woolwich, *c.* 1950. Present-day Kingsman Street is completely different from this down-at-heel scene. This picture was taken before the rebuilding of the whole of the St Mary's district of Woolwich in 1952 and 1961. The pub on the corner of Rectory Place is the George IV.

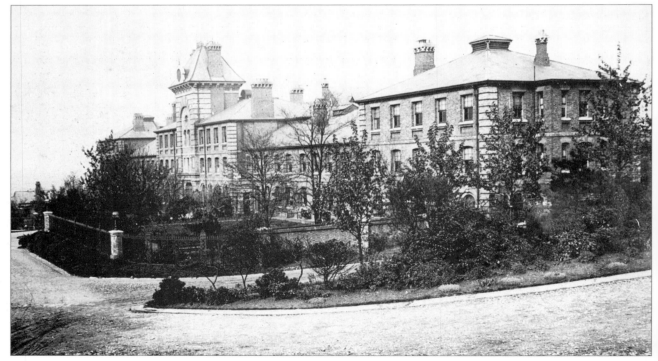

St Nicholas Hospital, Plumstead, *c.* 1910. Built in 1872 as Woolwich Union Workhouse, in 1929 it became St Nicholas Hospital and from then on many new wards and departments were built. The hospital was closed in 1986 and the site redeveloped.

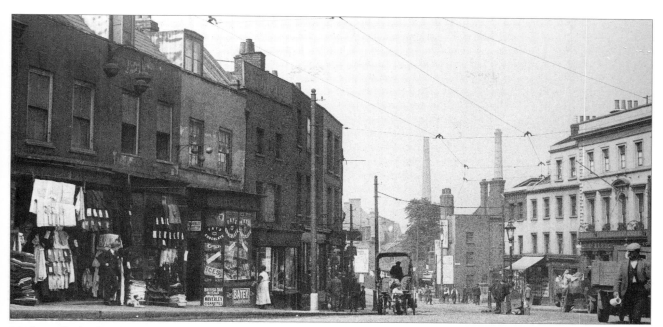

Market Hill, Woolwich, 1925. The left-hand side of this scene can be easily recognised today, but the right-hand side is much altered. The Waterfront Leisure Centre now dominates the bottom of the hill. Market Hill is part of Woolwich High Street and in the heart of the old riverside town. This is the view from just below the old market place (Market Head) looking down towards the approach to the old free ferry. On the left is an impressive display of goods outside Mr Thomas the pawnbroker's shop. Next door, at no. 106 in 1922, was Mrs Leach the confectioner. Alfred Skillman, furniture dealer at no. 108, provides a direct link with today: his family's name still appears above the shop. On the right, with a dustcart outside, is the Crown and Anchor public house – sadly no longer there. The man with the jug in the foreground may well have been on his way to the Steam Packet, another public house, long since demolished.

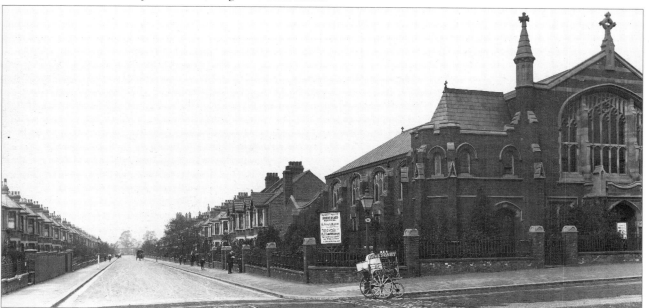

Earlshall Road, Eltham Park. The Eltham Park or 'Corbett' Estate was built between 1900 and 1914. Westmount Road, the principal road of the estate, contains churches, shops and a railway station. The station, opened in 1908, is now closed. Earlshall Road was one of the first roads to be built by the developer Cameron Corbett. The Methodist Church was built on the corner of Westmount and Earlshall Roads in 1906. A Howes' milk float from the Eltham Dairy can be seen in Westmount Road.

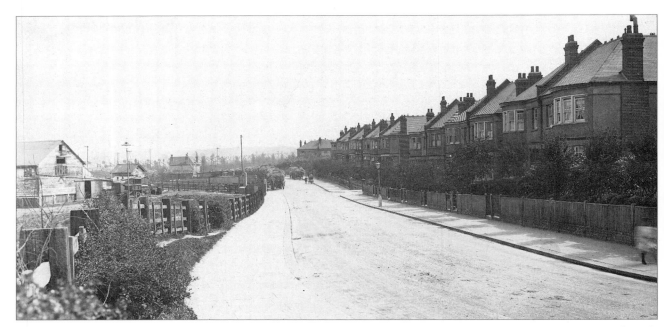

Sherard Gardens, Sherard Road, Eltham, *c.* 1915. Between 1906 and 1912 the Old Page Estate was built between Sherard Road, Well Hall Road, and land belonging to St John's Church. In 1905 Well Hall Road was extended in a straight line from the railway bridge to Eltham High Street. Before this the old road from Woolwich to Eltham turned sharp right along what was later to become Sherard Road. The new houses were close to Well Hall Station and, in 1915, still overlooked pleasant farmland.

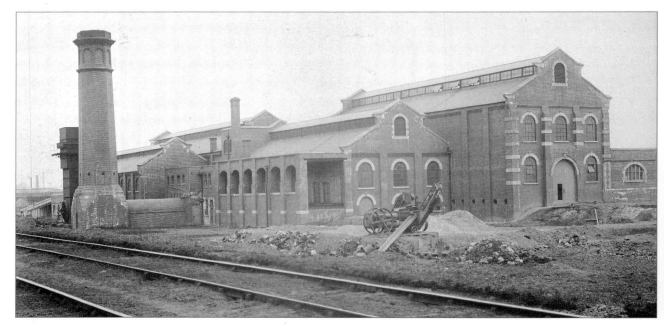

Woolwich Borough Council Power Station, Plumstead, *c.* 1923. In 1903 the White Hart Road combined refuse destructor, incinerator and power station was opened by the Electricity Department of Woolwich Borough Council. The council arranged terms for wiring the homes of local people for the supply of electricity and the purchase of electrical appliances. The borough promoted the use of electricity by building the first all-electric housing estate at Eltham in the 1920s. Between 1919 and 1923 a new power station was built in Woolwich resulting in the closure of the Plumstead site. The building became a council depot but the incinerator was still in use as late as 1965. White Hart Depot, as it became known, was closed along with other Greenwich Council depots in 1999.

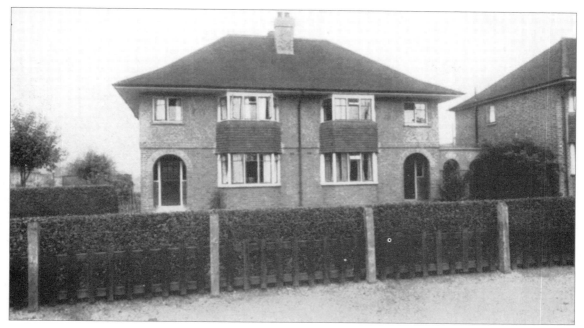

Page Estate, Eltham. The Page Estate was built for Woolwich Borough Council, 1929–30, on farmland from Eltham Hill to Rochester Way.

Woolwich Borough Council's Electricity Department, *c.* 1933. An advertisement from a Woolwich Municipal Tenant's Handbook for the council's Electricity Department. At that time electric power generation and distribution was the responsibility of a department of the council. The electricity was produced at the new power station, which stood on the riverside at Woolwich.

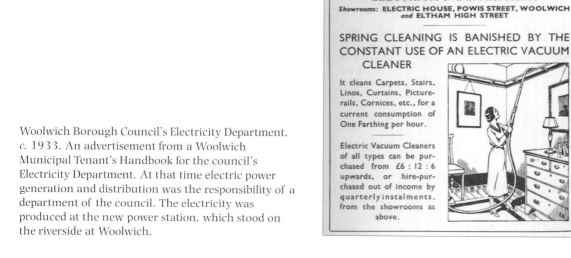

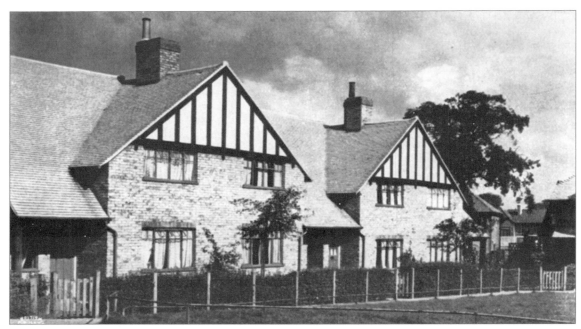

Middle Park Estate, Eltham. The Woolwich Borough Council built the Middle Park Estate between 1931 and 1936 on former royal parkland. Many of the families who came to live in the new estate had been rehoused from sub-standard housing on the Woolwich riverside.

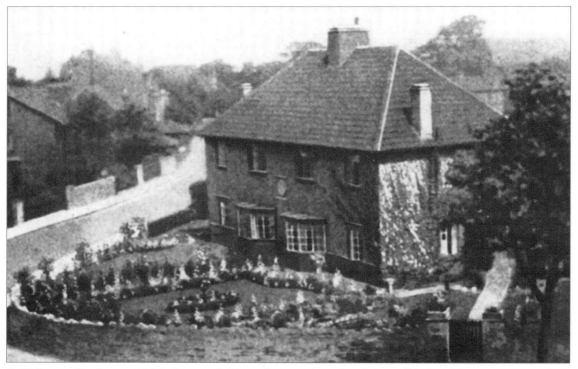

Guild Estate, Charlton. *c.* 1930. Greenwich Borough Council employed the Guild of Builders to construct their first housing estate in Charlton: the first houses were ready in 1921. These houses on the corner of Fairfield Road and Charlton Park Road were just part of this large estate of 164 dwellings built on the old Fairfield, home to Charlton Horn Fair in the nineteenth century.

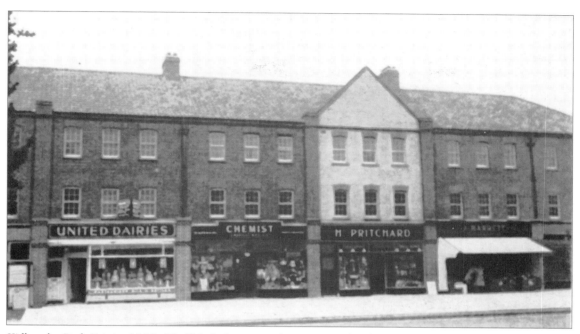

Kidbrooke Park Estate, 1929–30. This is from an advertisement for shops built to serve the new Kidbrooke Park Estate.

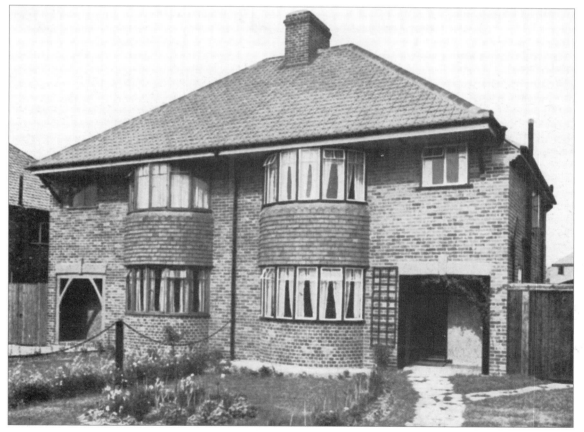

Two houses on Kidbrooke Park Estate, Shooters Hill Road.

WIMPEYS
SHOOTERS HILL
ESTATE

MODERN THREE BEDROOM HOUSES FROM

FREEHOLD £599 FREEHOLD

YOU CAN BUY ONE OF THESE
WONDER HOUSES FOR

15/7 PER WEEK

BUILT BY
GEORGE WIMPEY & Co., Ltd.

ESTATE OFFICES:- HEAD OFFICE:-

SHOOTERS HILL— (OPPOSITE WOOLWICH WAR MEMORIAL HOSPITAL)
TEL: WOOLWICH 1000. 27 THE GROVE,
 HAMMERSMITH W.6.
PAGET ROAD—
TEL: WOOLWICH 1033. TEL: RIVERSIDE 4801.

THE WEEKLY REPAYMENTS ARE BASED ON MORTGAGE RATES IN FORCE AT
DATE (JUNE 1933) BY THE LEADING BUILDING SOCIETIES. THE MORTGAGE
BEING OBTAINED THROUGH OUR AGENCY.

Wimpey Estate, Shooters Hill, 1930s. This advertisement for 1930s housing on the top of Shooters Hill is striking, not least for the price.

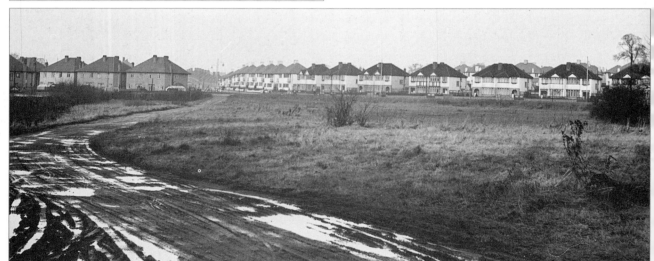

Kidbrooke Green, Rochester Way, 1938. The Rochester Way Relief Road, completed in 1988, virtually cut Kidbrooke in half. Traffic now thunders along a cutting which has enveloped most of Kidbrooke's village green. The muddy track in A.R. Martin's photograph of 1938 led to Lower Kidbrooke Farm and its smelly piggeries. The houses facing the green survived the major demolition of buildings in Rochester Way when the Rochester Way Relief Road was being built.

War

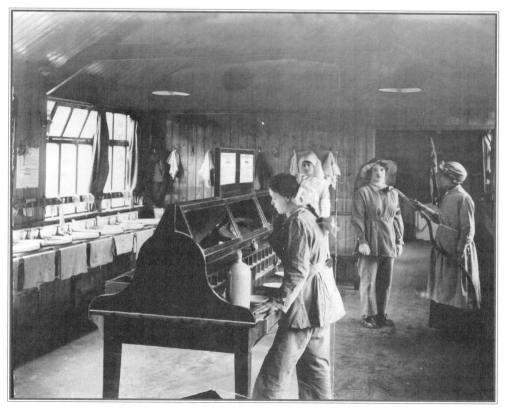

'Lyddite Girls' in a cleansing room at Kings Norton Ammunition Works, Abbey Wood, *c.* 1916. During the First World War many women employed in the Woolwich Arsenal and the Kings Norton works filled explosive shells in 'Danger Buildings' on the Plumstead and Erith marshes. Lyddite or picric acid (trinitrophenol) is not only a dangerous high explosive but can, and did, turn hair and skin yellow. Nicknamed 'canaries' young women worked twelve-hour shifts and, because of the danger, earned higher wages. In order to protect their health special canteens provided them with extra food and milk. In the cleansing room all outer garments, jewellery and metal objects had to be removed to reduce the danger from sparks. Uniforms and veils were vacuum cleaned to remove anything else that might trigger an explosion. Hands and faces were washed with disinfectant, and a special grease applied to neck and face. Local chemists prepared skin and hair dyes to reduce the disfigurement caused by lyddite poisoning.

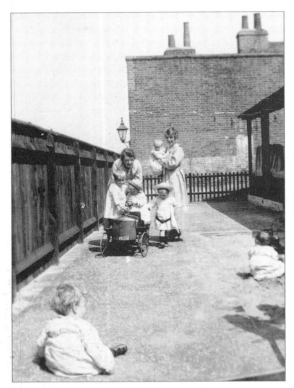

Crèche for children of women workers, Woolwich Arsenal, *c.* 1916. These are nurses with their young charges in a playground attached to the crèche. After 1915 the Ministry of Munitions authorised a payment of *7d* a day per child for minding the children of munitions workers. Dame Lillian Barker, the Lady Superintendent of the Royal Arsenal, opened seaside retreats for mothers and babies in addition to the facilities offered within the Arsenal.

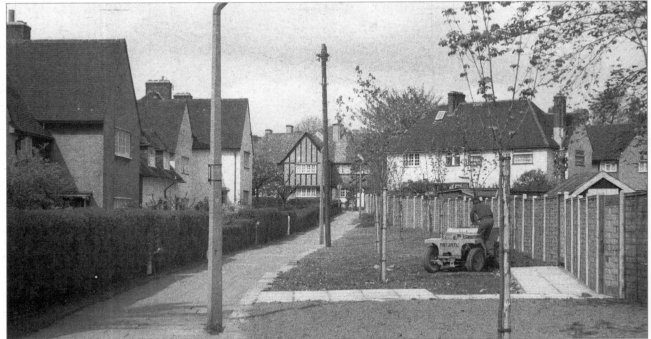

Progress Estate, Well Hall, Eltham. The government built this 'garden suburb' estate in 1915 to house wartime workers at the Royal Arsenal in Woolwich. The Royal Arsenal was operating at peak production during the First World War and employed a record number of workers for whom homes needed to be built. Originally known as the Well Hall Estate it was renamed after it was bought by the Royal Arsenal Co-operative Society in 1925. It is now acknowledged as one of the most interesting estates built in the twentieth century. A housing association maintains those properties not in private hands.

Shepherd's Farm Hutments, Eltham, *c.* 1930. Denis Healey, recalling his childhood in Eltham, wrote: 'In my earliest days we lived on an estate of wooden huts, which had been put up as temporary housing for some of the 80,000 workers needed at the Woolwich Arsenal during the Great War.' Even as the Progress Estate was being finished in 1915 it became obvious that many more homes would be needed for the munitions workers. As a result hut estates were built on the Eltham side of Shooters Hill, and at Plumstead and Abbey Wood. The misspelt Shepherd's Farm Hutments were built on land belonging to Edward Sheppard of Well Hall Farm. These huts stood between the Progress Estate and Kidbrooke Lane. In the 1930s they were pulled down to make way for the building of St Barnabas Church, Rochester Way, the Well Hall roundabout and the Odeon (now Coronet) cinema.

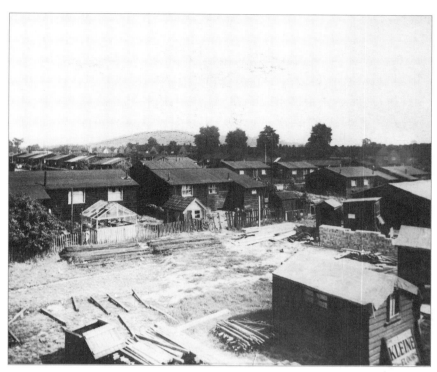

First World War Victory Party, Straightsmouth, Greenwich, 1919. St Alfege's Church towers over the peace celebrations in Straightsmouth. There were spontaneous parties when the war ended on 11 November 1918 but this organised party was held over until the following spring.

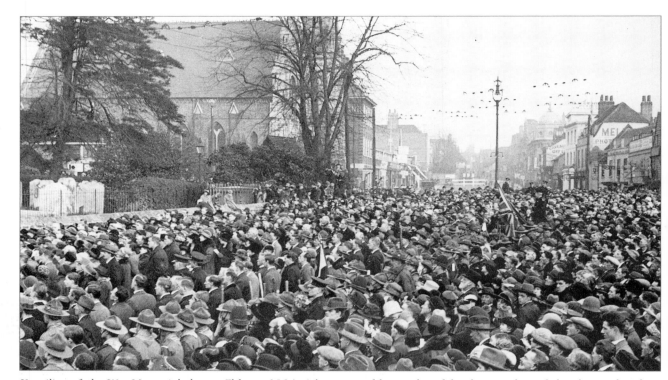

Unveiling of the War Memorial plaque, Eltham, 1924. A large crowd has gathered for the unveiling of the plaque placed on the wall of St John's Church, Eltham, in the High Street. Beyond the sea of hats can be seen Eltham Congregational Church. This was demolished in 1935 and McDonald's Restaurant and the shops in Merlewood Parade stand on the site. Opposite the church are two old weatherboarded houses, also now demolished, and the Greyhound public house, built about 1720. This pub was completely rebuilt in 1978 but retains the appearance of the original building. Next door to the pub is the easily recognisable Mellins shop. In 1924 it was the village chemist, but now it is a wine bar.

The Second World War

By 1938 the crisis in Europe had deepened to such an extent that war was seen to be inevitable. Britain would be at war with Germany again only 20 years after the 'War to end all wars' had finished. Preparations to safeguard the civilian population were made, and thirty-eight million gas masks were distributed. In addition an emergency scheme was drawn up to evacuate London's children to safer areas. Neville Chamberlain flew to Munich on 29 September 1938 and schoolchildren took their cases into school halls to await the outcome of his meeting with Adolf Hitler. 'Peace for our time . . . peace with honour' was the prime minister's message and the children went home. However, war was declared on 3 September 1939.

In August 1940 the Battle of Britain produced many 'red alerts'. A serious incident for local people was at Plumstead where a Messerschmitt 110 crashed into two gardens, trapping the occupants in their Anderson shelters. One woman died and others were badly injured. On the afternoon of 7 September 1940 waves of bombers flew over east and south-east London. The noise of the bombers, bombs and anti-aircraft guns marked this raid as very different from any previous attacks: the blitz had begun. Memories differ but everyone remembers the flames from the docks, factories and houses on both sides of the Thames. The blitz caused terrible pain and suffering and the damage to buildings and landscapes was awesome. As we have mentioned before many families in North Woolwich who had lost their homes were brought to Woolwich during the first night of the blitz on the Woolwich ferry boats. The crews sailed the boats through the night, avoiding bombs and fire.

It seemed that nothing would be the same again, and as far as the landscape was concerned it never was. The blitz ended in June 1941 but it was certainly not the end of either the war or the aerial bombardment.

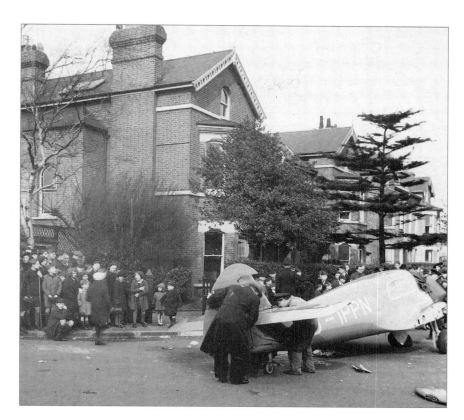

German plane in Talbot Place, Blackheath, March 1939. A.R. Martin, a prominent member of the Greenwich and Lewisham Antiquarian Society, was on hand to take this photograph of a German plane, which landed in Talbot Place. The pilot claimed that he mistook the flat, grassy plain of the heath and the gardens in Talbot Place for Croydon Aerodrome. Local people were incredulous, believing this to be a spy plane.

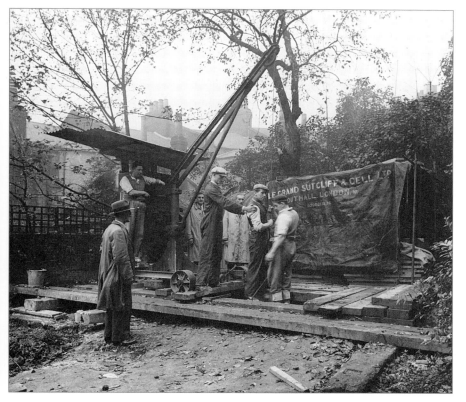

Entrance to Blackheath Caverns, in the garden of 77 Maidenstone Hill, Greenwich, October 1939. In 1914 John M. Stone, an antiquarian, wrote about the caverns under the Point at Blackheath and Maidenstone Hill. He stated that 'all traces of the entrance have now been lost'. In 1939 Greenwich Council instigated a search for the entrance, intending to use the caverns as bomb shelters. The engineer and the diviner that the council employed found the entrance in the back garden of 77 Maidenstone Hill.

Inside Blackheath Caverns, October 1939. Greenwich Borough Council officials had to decide whether it was feasible to use the caverns as air raid shelters. The cost of constructing new entrance and exit tunnels and the discovery of subsidence caused the project to be abandoned. Members of the Greenwich and Lewisham Antiquarian Society (now the Greenwich Historical Society) explored the caverns in 1946. The entrance was sealed when their investigation was finished.

Anderson air raid shelter, Granby Road, Eltham, *c.* 1960. As air raid precautions were increased in November 1938, Sir John Anderson was put in charge of protecting the civilian population. Anderson garden shelters were distributed to homes in vulnerable areas and, by late 1939, many gardens contained one of these strange corrugated-iron structures, half below and half above ground. They were cold, damp, dripping with condensation, and offered protection only against blast. It was hoped that they would not be needed. However, they could look very decorative as adventurous gardeners grew flowers and vegetables in the soil that covered them. Local newspapers sponsored competitions for the best-cultivated shelter. Most were dismantled and taken away by the authorities after the war but a few lingered on in back gardens, often serving as an extra garden shed or a play area for children.

P. Weller, Westcombe Hill, Blackheath. The 'Dunkirk Spirit' is very much in evidence here as Mr Weller fights off multiple adversities. As evidence of their staying power Weller's Travel Agency can still be found at Stratheden Parade, opposite the Royal Standard public house.

Bershaw's Trafalgar Road, Greenwich. It seems that not all local people were suffering equally in 1942!

Vanbrugh Guild of War Workers, 1942. This eating place for war workers founded by Captain Herbert Ansell offered cheap, nutritious food. It is claimed to be the forerunner of the British Restaurants which were common throughout England.

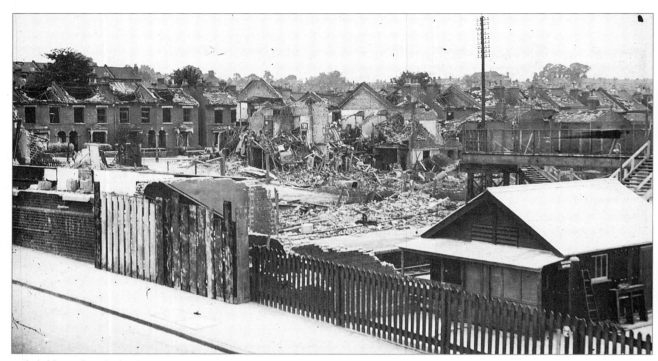

Delafield Road and Charlton station. On 23 June 1944 a V1 bomb fell on Charlton Church Lane, destroying some houses in Delafield Road. Three people were killed and at least ten others injured. Charlton station was badly damaged. The station which was subsequently rebuilt is now due for further modernisation as it will be used by thousands of visitors to the Millennium Dome who arrive by rail. The occupants of these prefabs in 1961 must have been extremely well informed about the local train services, judging by the position of the loudspeaker!

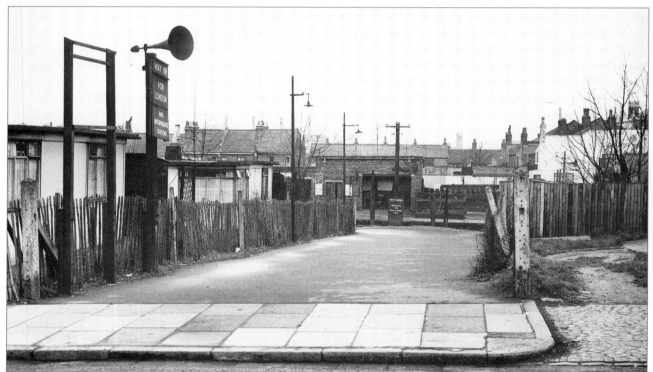

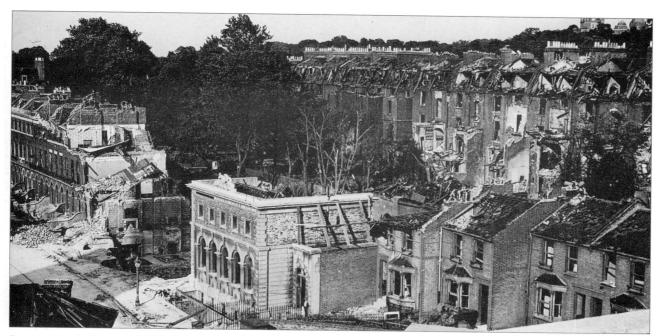

Burney Street, Greenwich, 27 June 1944. This photograph taken from the roof of Greenwich Town Hall (now Meridian House in Greenwich High Road) shows the extensive damage caused when a V1 bomb landed on the houses next to the Crown Court at the Royal Hill end of Burney Street. Houses were blown to pieces, and the court stands roofless and blasted. The north side of Gloucester Circus was also damaged. As a result of the damage the court and houses on both sides of it were demolished. 'Maribor' and Greenwich Police Station now stand on the site.

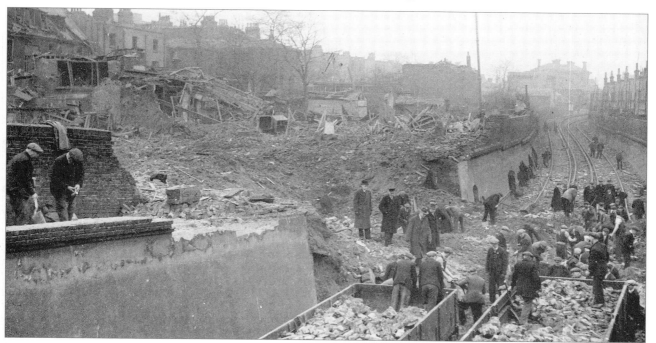

Bomb damage on the railway at Greenwich, 1 July 1944. It was amazing that no one was killed when a V1 exploded on the track between Straightsmouth and Greenwich High Road. Property in Greenwich High Road was badly damaged and trees were stripped of their leaves. Greenwich station, which can be seen in the background, and houses in Straightsmouth (on the right) received blast damage.

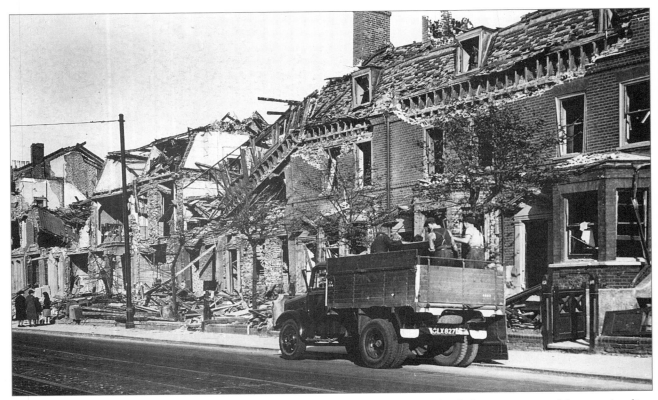

Greenwich High Road, 12 July 1944. Eight houses were destroyed when a V1 landed on a terrace of houses standing between West Greenwich House and Lovibonds the brewers (now Davy's Wine Vaults).

After this V1 incident the Civil Defence reported that the church was 'wrecked'. People trapped in nearby houses were buried and had to be dug out. The Heddle family was the last to be rescued. The ARP report said: '07.17 Miss Heddle rescued alive; 07.45 Mr Heddle, Jnr, rescued alive; 09.16 Mr Heddle, Snr, rescued alive. Incident closed.' St Mark's Church was rebuilt in 1953. The congregation had used a pre-fabricated building since the bombing.

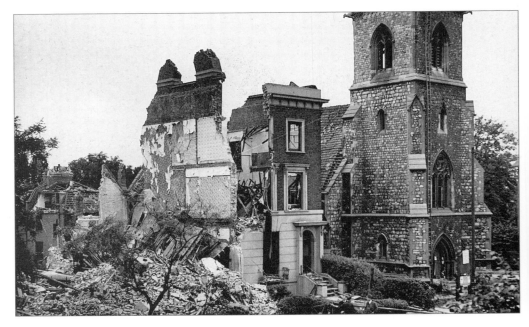

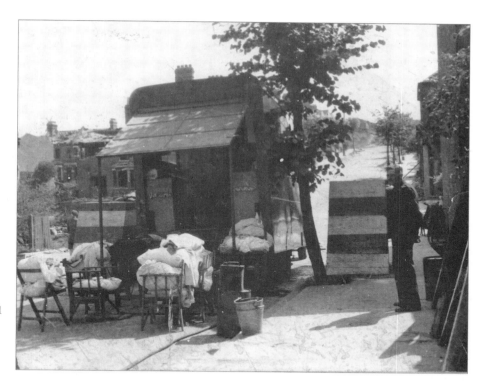

Admaston Road, Plumstead. A V1 hit Admaston Road on 4 August 1944. Essential supplies were cut off for a time so the street was supplied with a mobile laundry.

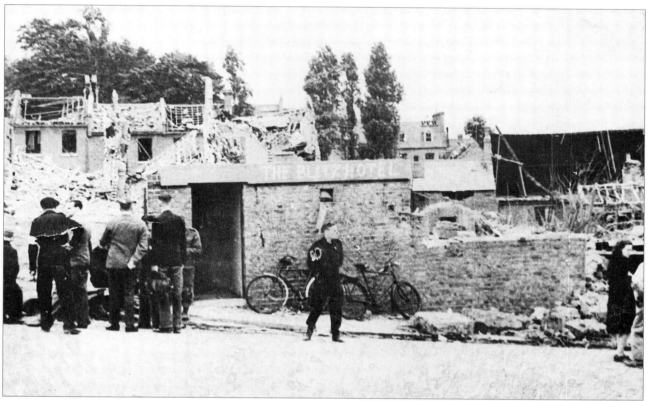

Milward Street and the corner of Nightingale Vale, Woolwich, 31 July 1944. A V1 fell on houses in these streets. Two people were killed and at least fifty-three were injured. Local people and ARP workers talk it over outside the nicknamed 'Blitz Hotel'.

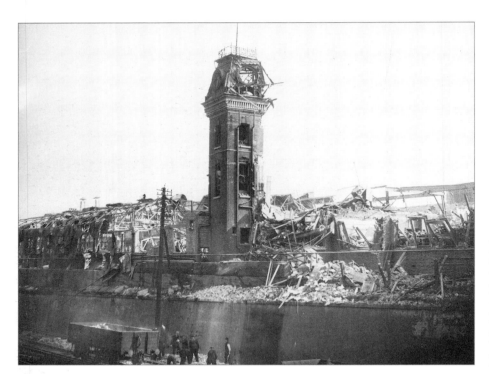

Johnson & Phillips, Victoria Way, Charlton, 9 March 1945. One of the last V2 rockets to fall in the Borough of Greenwich hit the Cable Department of Johnson & Phillips Electrical Works. The factory had been bombed before but the tower survived until the last weeks of the war in Europe.

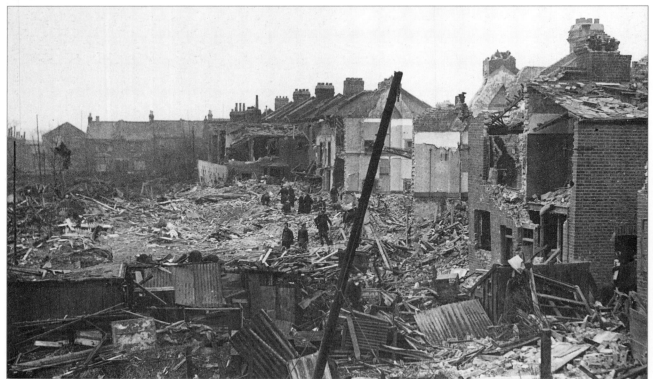

'All services required!' at Troughton Road, Charlton, 8 February 1945. At 5.50 p.m. a V2 rocket smashed into Troughton Road and the rear of Woolwich Road, killing eleven people and causing immense damage. As with all V2 attacks there was no warning as they could not be seen or heard. The homeless went to Fossdene Road Rest Centre. Rescue work continued until the Civil Defence workers were satisfied that everyone had been recovered from the debris.

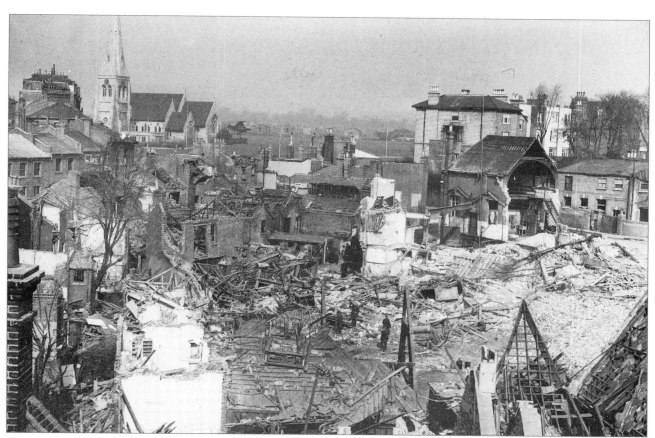

Blackheath Village, 8 March 1945. This scene of devastation was caused by a V2 rocket, which hit the Wesleyan Church in Blackheath Grove. Beyond the terrible damage can be seen All Saints Church, and the rows of Nissen huts which housed the crews who operated the anti-aircraft guns on the Heath. Greenwich Park is in the far distance. The bomb site was never developed – a car park is on the site today.

Prefabs in Tunnel Avenue, October 1961. These temporary Second World War prefabricated houses became permanent homes for many people whose houses had been destroyed or badly damaged in the bombing raids. Many people grew to love their prefabs and missed them when they were rehoused.

Victory flags at Johnson & Phillips factory, 10 May 1945. The victory flags are flying from a newly built block in Victoria Way, Charlton. The firm had started to replace bombed buildings before the end of the war. This block was completed in time to be decorated for the celebrations.

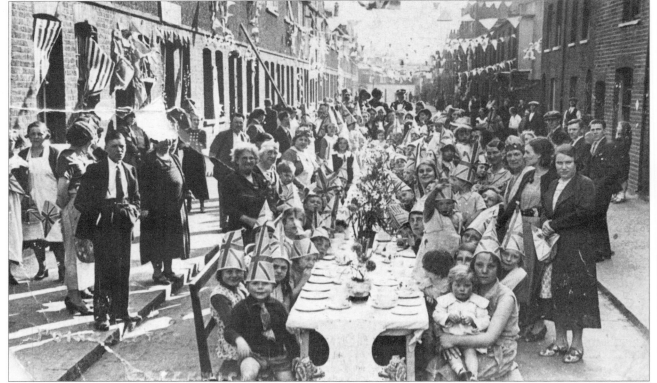

Second World War victory party, Straightsmouth, Greenwich, May 1945. This party was held to celebrate the end of the second terrible war to blight the twentieth century. The war in Europe ended on 8 May 1945. At last the bombing was over and the forces would soon be coming home. This was a party for the children. A good spread was laid on even though food was still rationed. There were street celebrations again when the Japanese government surrendered on 14 August of the same year.

Reaching for the Sky: Building after 1945

Clockhouse Community Centre and Woolwich Dockyard Estate, 1998.
Woolwich Dockyard was founded by Henry VIII in 1512. Hundreds of Royal
Navy vessels were built there until its closure in 1869. Greenwich Council
acquired the eastern part of the yard and developed it as a housing estate.
Between 1973 and 1980 new streets were laid out and a mixture of houses
and flats constructed. Certain original features were kept including the
Clockhouse, built as offices in the 1780s, and the Gatehouse built at a
similar time. Unfortunately, the Gatehouse is empty and unused at present.
The Clockhouse was restored and is a flourishing community centre. A gun
drill bastion and two docks were also retained on this site.

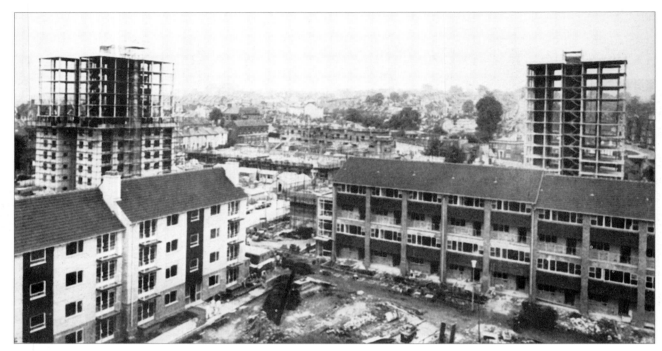

Glyndon Estate, Plumstead. In 1957 Woolwich Borough Council started to demolish houses in Plumstead in order to build a new estate. Villas, Glyndon, and Conway Roads were just a few of the streets affected by the Glyndon area redevelopment. Tower blocks of eleven storeys, the first high rise flats in the borough, were planned. The picture shows the estate under construction. The first buildings to be finished were twenty-four one-bedroom flats in Ann Street. The Mayor of Woolwich, Mabel Polley, opened these in November 1962. Guests were invited into no. 138, the new home of Mr and Mrs Hopgood. In 1998 the refurbishment of the Glyndon Estate began but the Conway Road tower block was found to be beyond repair and, in May 1999, demolition work started.

Corner of Plumstead Road and Invermore Place, *c.* 1979. Posters advertising bands Slade and Motorhead cover the boarded-up windows of the Tunnel Tyre Service. 'Cheeks', a Deptford night-club housed in the old Broadway cinema, advertises its 'Party Nights'. These old houses and shops are awaiting demolition prior to the development of Plumstead Road in the 1980s.

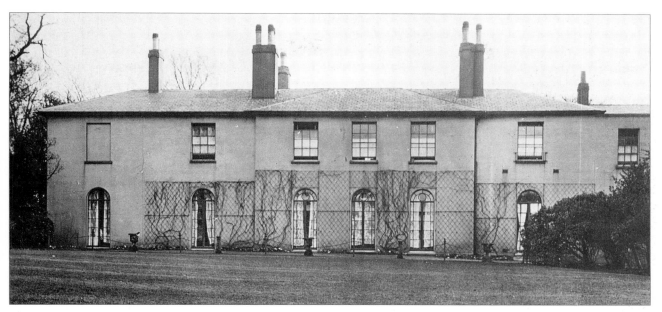

East Mascalls, Charlton Road, 1937. Before 1939 Old Charlton was the name given to Charlton Village and its immediate environs – an area still with a rural atmosphere. In the first half of the twentieth century at least six old houses with large gardens stood in Charlton Road in an area bounded. on the north, by Bramhope Lane and Victoria Way and, on the south, by Marlborough Lane and Rectory Field. In the mid-1930s Greenwich Borough Council compulsorily purchased the houses and land for council housing. Development was delayed by the war but building work continued till the 1950s. By the time construction was complete the rural elements of Charlton had all but gone.

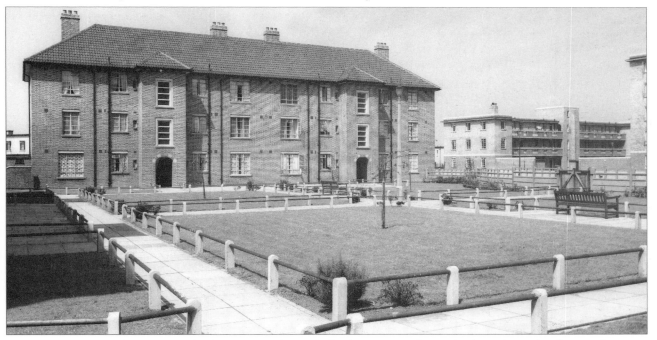

The Glade, Cherry Orchard Estate, Charlton, 1952. Cherry Orchard House together with The Cedars, The Elms, High House, Fairlawn, and Floyds on Charlton Road were acquired by Greenwich Borough Council in 1936. The houses were demolished and the ground cleared by 1945 when work began on the Cherry Orchard Estate. The first block was opened in 1947 and, one year later, the estate was visited by Princess Elizabeth (now the queen), and Prince Philip. The estate was developed between 1945 and 1952 with a variety of styles of architecture. The Glade is on its southern boundary towards Shooters Hill Road.

Old Woolwich Road, *c.* 1936. Old Woolwich Road was the original main road from Greenwich to Woolwich until 1825 when Trafalgar Road was constructed. This group of houses with nineteenth-century shopfronts stood next to the garden entrance of Trinity Hospital Almshouses. The gate to Trinity Hospital can be seen on the right. The chimneys and western wall of Greenwich Power Station are glimpsed beyond the houses and garden. By 1938 the advertisements for Lyons Tea and Packers Chocolates had disappeared as Jennings House of the newly built Ernest Dence Estate arose on the site of these buildings.

Benares Road, Plumstead, 1972. Councillor Marie Kingwell, Mayor of Greenwich, opens one of two show houses prepared by Greenwich Council as part of the 'Improvement of older property' campaign. The campaign ran in April and May and was designed to make people aware of the improvement grants system.

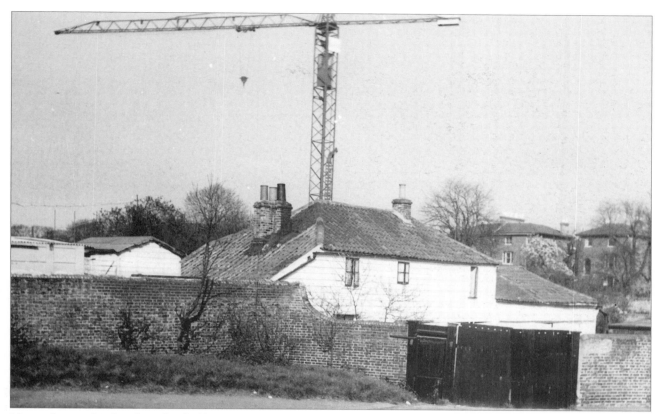

Manor Cottage, Vanbrugh Park, Blackheath, April 1961. This weatherboarded cottage stood on the corner of Vanbrugh Park and Vanbrugh Fields. In 1847 it still had fields behind it but, as Victorian houses grew up around it, the occupants no longer let out land to farmers. This charming cottage survived the war intact but was demolished to make way for the Parkside flats.

The Manor House and Parkside, Vanbrugh Fields. The interesting house that is being demolished in this picture was built in 1726 as part of Sir John Vanbrugh's Blackheath Estate. It had large drawing and dining rooms and, in 1798, was described in an advertisement as 'an elegant small house'. Known as the Manor House its address was 1 Vanbrugh Fields. By the early 1960s it stood in the way of the completion of the Parkside development.

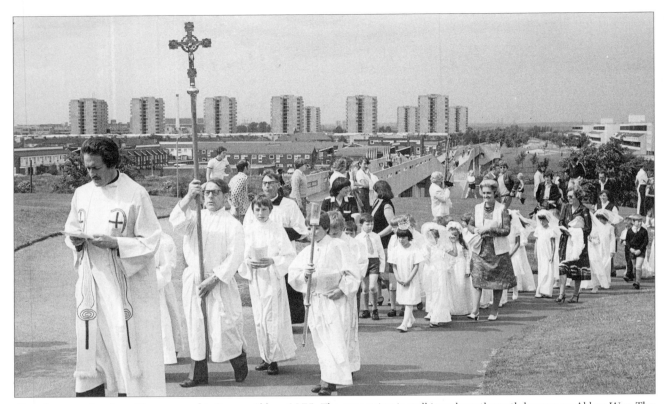

Church procession from Thamesmead to Lesnes Abbey, 1975. The procession is walking along the path known as Abbey Way. The bridge over the main road and the railway leads the walkers from the modern architecture of Thamesmead to the ancient ruins of the abbey, founded by Richard De Luci in 1178. In this view can be seen the high-rise flats and tiered blocks designed by the Greater London Council architects in the late 1960s. The development overlooks Southmere, the largest of the lakes in Thamesmead. By the end of the 1970s the building of high-rise blocks had ceased, and further developments consisted of low-level housing.

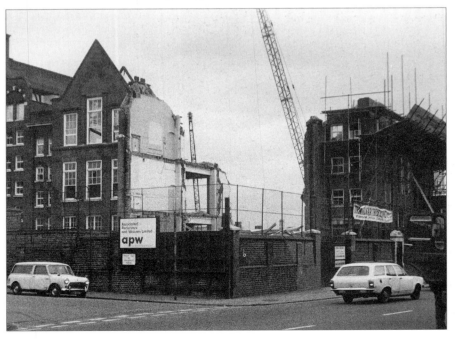

Demolition of Charlton Secondary School for Boys, Woolwich Road, Charlton, 1979. Lombard Wall School was opened in 1884. When the London County Council took over responsibility for London's schools in 1904 it became a mixed junior and senior school with an infants' department. Between 1939 and 1945 part of the school was used by the Auxiliary Fire Service and other wartime services. Built amid the heavy industries of Charlton the buildings suffered much bomb damage. After 1945 the name was changed to Charlton Secondary School for Boys. In 1976 it was merged with the John Roan School on Blackheath. The school closed in 1979 and, a few weeks later, demolition started. In 1985 the new East Greenwich Fire Station opened on the site.

All Change in the High Street

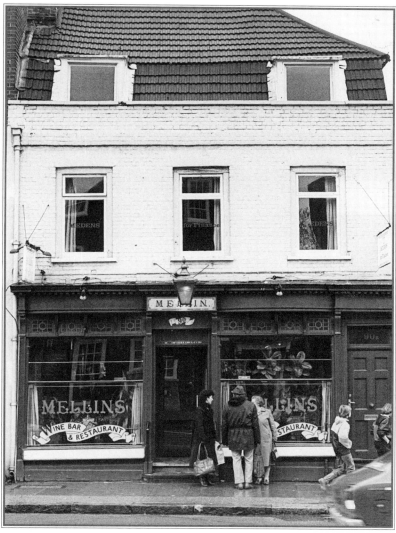

Mellins Wine Bar and Restaurant, Eltham High Street, *c.* 1980. Once the place for purchasing pills, potions and toiletries it now dispenses wine and food. A chemist's shop was established in this early eighteenth-century building in the 1860s, the business being carried on until 1976. Fortunately, the fashion for dining in interesting old buildings helped to preserve the place where Mellin made up his special medicines for coughs, colds and stomach-ache.

Eltham High Street looking east from Passey Place, 1949. The ABC cinema was built on the corner of Passey Place and Eltham High Street in 1922. Closed in 1972, shops now stand on the site. The gas industry was nationalised in 1948 and the gas showrooms, built on the site of Eltham House, have been taken over by the newly formed South Eastern Gas Board.

Woolwich New Road, c. 1910. This Edwardian scene is recognisable today although Peggy Middleton House now dominates the right-hand side of the road replacing the barracks formerly on the site. The Gun Tavern is no longer a public house but the building is easily recognised. The Presbyterian Church, beyond St Peter's Catholic Church, has been demolished but most of the other buildings have survived. The oil jars high on the wall of no. 81 indicate that this was George Mence Smith's Oil and Colour shop.

Woolwich High Street, *c*. 1910. It would be difficult to recognise this view today. This is Woolwich High Street at the junction with Hare Street and Ferry Approach. The buildings on the right have been demolished in order to create a dual carriageway. Ferry Approach on the right-hand side no longer exists: the Waterfront Leisure Centre covers the site and the Granada cinema (now a bingo hall) cuts off the view of St Mary's Church. Some of the buildings on the left-hand side remain, including Plaisted's.

Powis Street, Woolwich, *c*. 1925. This street was the hub of Woolwich's shopping area. All the best-known department stores were there as well as many specialist shops. Pryce and Son, printers and stationers, were next to Carter and Sons, hatters and hosiers. Goods could be bought on hire purchase (credit) at Wood Bros furniture stores. Across the road, barely visible here, Garrett and Cuffs department stores stand on opposite corners of Macbean Street (formerly Union Street). Nearer the camera Samuel's the jewellers are advertising their 'Lucky wedding rings', and gas lamps decorate the front of the South Metropolitan Gas Company's showrooms.

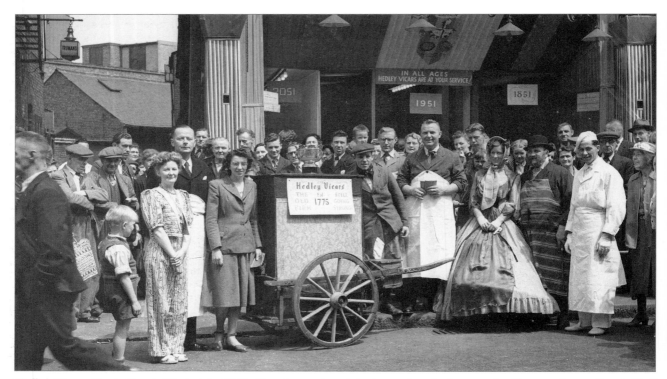

Hedley Vicars, Powis Street, Woolwich, 1951. Dressing up to celebrate one hundred years of selling meat were the staff of this butcher's shop, next to the Star and Garter public house on the corner of Powis Street and Hare Street. Both shop and pub have now gone but all was optimism then when they created the slogan 'In all ages Hedley Vicars are at your service.'

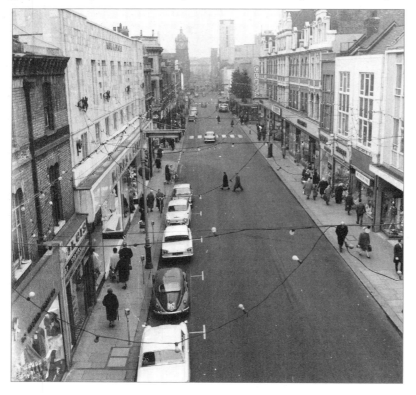

Christmas in Powis Street, Woolwich, 1965. Powis Street is full of Christmas lights and decorations. Large Christmas trees stand over the canopy of Cuffs department store. Garretts, another well-known large store, is housed in its original 1898 building. The upper floor of the building, decorated with the Invicta horse of Kent, can still be seen today although the store has gone. At the end of the street are two tall buildings belonging to the Royal Arsenal Co-operative Society. The RACS was founded by a group of Royal Arsenal workers in 1868 and rapidly expanded to become one of the largest co-operative societies in England. Out in the country many miles from London branches of the RACS could be found! The building with the clocktower dates from 1903, the society's building on the other side of the road from 1938. The RACS no longer exists but both buildings have survived. The RACS was taken over by the Co-operative Wholesale Society in 1985.

Powis Street, Woolwich, *c.* 1972. Powis Street was first laid out in about 1798 and, like most shopping streets, has been subject to many changes. Between 1890 and 1910 the majority of the original buildings had been replaced with much smarter structures that reflected the street's status as the prime shopping area of Woolwich. In the late 1960s, however, further buildings were demolished and, in 1974, the nineteenth-century public house the Shakespeare Hotel was threatened with demolition. It can be seen here next to Lipton's and immediately behind the no. 51 bus. The Shakespeare had a reputation for good quality entertainment. In the late 1940s traditional jazz bands played there and, in 1973, Thames Television arranged a Monday night entertainment programme which included the Barrow Poets. A few years later the pub was demolished, removing a most attractive façade from Powis Street.

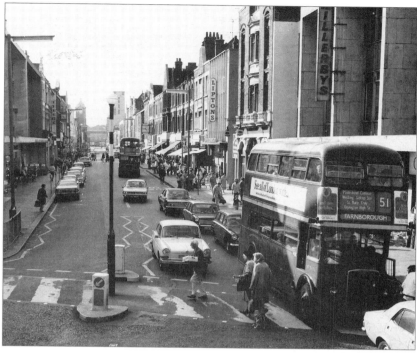

McDonald's Restaurant, Powis Street, Woolwich, November 1974. Boxer Henry Cooper is signing copies of his autobiography in the restaurant. The young fans crowding around were eager to get his autograph even if they could not afford to buy the book.

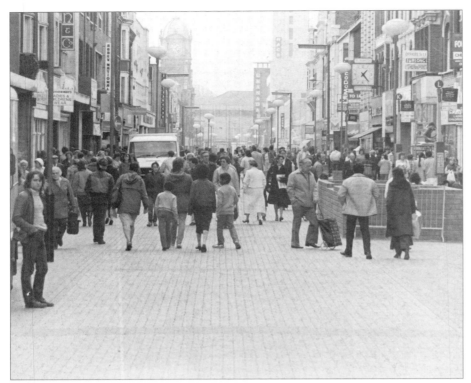

'Pedestrians only' in Powis Street, Woolwich, *c.* 1986. In 1973 Greenwich Council decided to pedestrianise Powis Street. One trader said, 'People are fed up with coming here and having to fight their way across the road.' The plan was considered again later but it was not until the 1980s that the traffic was diverted and landscaping of the street took place. Buses were re-routed and in the mid-1990s the pedestrianised area was given a face-lift.

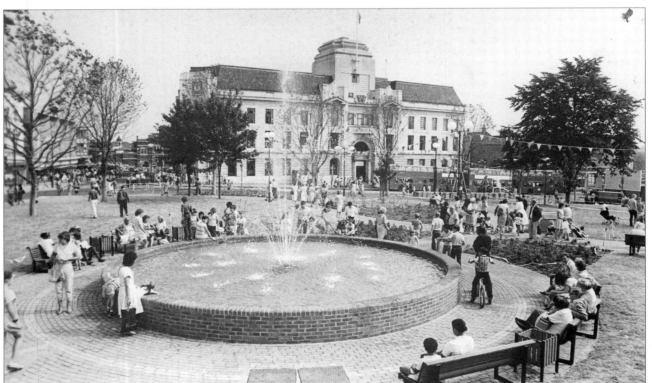

The Town Square, Woolwich. The Town Square, an attractive feature of central Woolwich, was created in 1983 when a proposed redevelopment of the area between Thomas Street and General Gordon Place was abandoned.

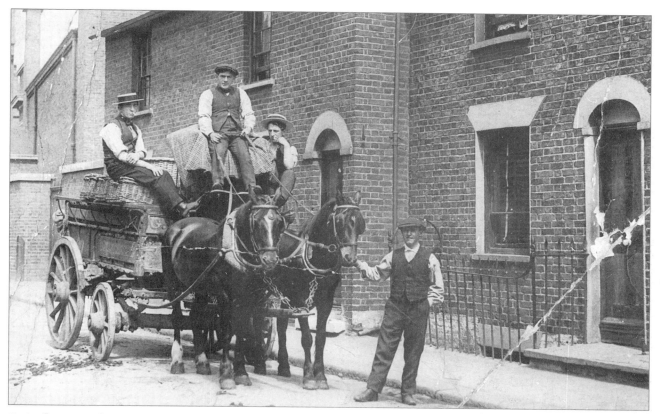

Fruit, flowers and greengrocery – the Manchester family of Woolwich Market. *c.* 1925. George Manchester was born in Greenwich in 1862 and died in Woolwich in 1955. He had been a greengrocer since the late 1870s and, after marriage and a move to Woolwich, he created a long-lasting family business. He sits on his cart in Wilmount Street, Woolwich, surrounded by other family members. Family tradition in Woolwich Market is strong and when George died many stallholders could claim relationship to him by direct descent or by marriage.

Beresford Square, Woolwich, 1939. Woolwich Market officially moved into Beresford Square in 1888 although unofficially it had been there longer. It became a very popular open-air market as well as a convenient area for political meetings. Meetings were a source of free entertainment especially when a witty heckler was in the crowd. Traffic, including trams, moved freely through the market putting the onus on pedestrians to keep out of the way. It could be alarming to step back from a stall and find a large tram too close for comfort! The tram went on to Woolwich New Road via Greens End and Thomas Street. The lower part of the Beresford Gate, the main entrance to the Royal Arsenal, was built in 1829, the upper part in 1891. The gate is now separated from the Arsenal by Plumstead Road and has become instead a feature of the square rather than an integral part of the Arsenal.

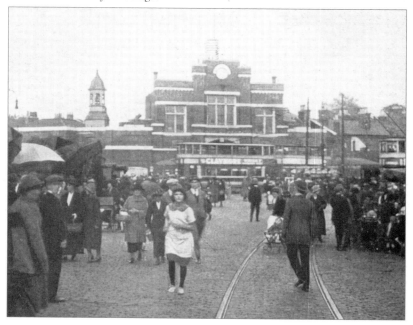

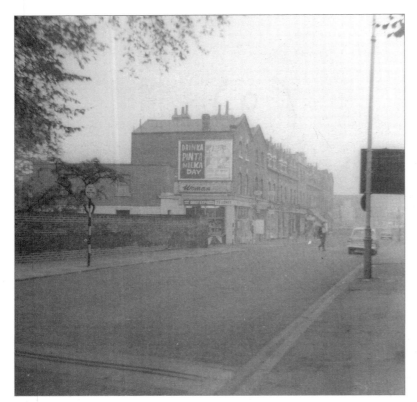

Delacourt Road, Blackheath, *c.* 1968. These purpose-built late nineteenth-century shops along with those in Old Dover Road became a popular shopping centre. By 1970 all the shops in the picture, including the remainder of the terrace not shown here, had been demolished to make way for the Blackwall Tunnel Southern Approach Road. During the excavation for the new road a section of road, possibly Roman, was uncovered close to Sunfields Memorial Church and near the junction of Old Dover Road and Delacourt Road. The contractors would not stop the work to enable the section to be recorded but those present were certain that they had seen an ancient road.

Old Dover Road, Blackheath, *c.* 1965. Jimmy Edwards, the late comedian, smiles out from the Toby advertisement above the Royal Star Café in Old Dover Road, before all the shops lining the road were demolished to make way for a deep cutting needed for the Blackwall Tunnel Approach Road. At the beginning of the 1960s a second Blackwall Tunnel was under construction, and a new approach road was commissioned. A swathe was cut through many streets from the Greenwich Peninsula to the Sun in the Sands roundabout on Shooters Hill Road. Many houses and shops had to be demolished.

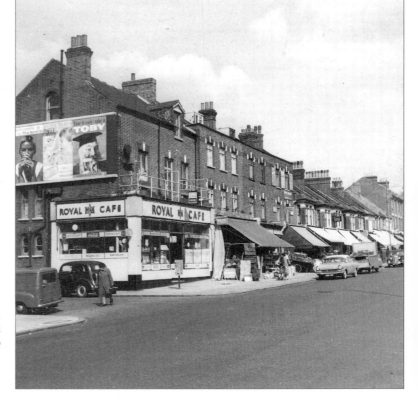

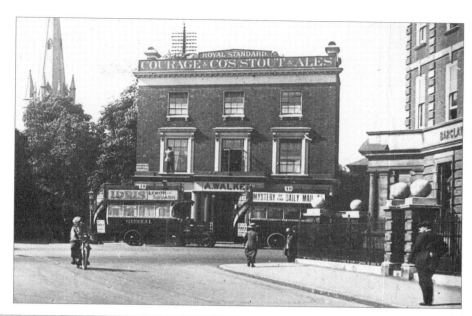

Royal Standard public house, Vanbrugh Park, Blackheath, *c.* 1925. The public house and three shops adjoining were built in 1848. St John's Church, at the heart of the Victorian development of this part of Blackheath, was consecrated in 1853. Victorian houses and shops were built and then, in 1906, a London and Provincial bank opened – to be taken over by Barclays in 1921. Heavy traffic going around the busy roundabout has replaced this tranquil scene.

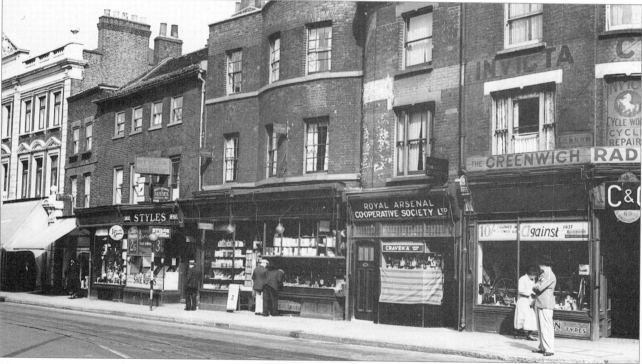

Greenwich High Road, south side, 1937. Before the Second World War this road, formerly known as London Street, was full of shops and trams. The impressive building on the far left housed the Workshops for the Blind, built in 1892. Between Styles, the shoe repairer, and the Royal Arsenal Co-operative Society's tobacco shop browsers are looking in the window of Glaisher's Bookshop. Founded by Henry Glaisher in the mid-nineteenth century it soon gained a good reputation. Henry Glaisher's brother was James Glaisher FRS, the celebrated balloonist, who worked at the Royal Observatory in Greenwich. They both died at the beginning of this century and Henry's son James inherited the business. C&C Motors, with the White Horse of Kent over the door, graces the corner of Greenwich High Road and Royal Hill. All these old buildings have gone; some bombed, others demolished for redevelopment in the 1980s. Of the old buildings only some masonry from the Workshops for the Blind survives. It has been incorporated into a redeveloped area roughly on the site of the original building.

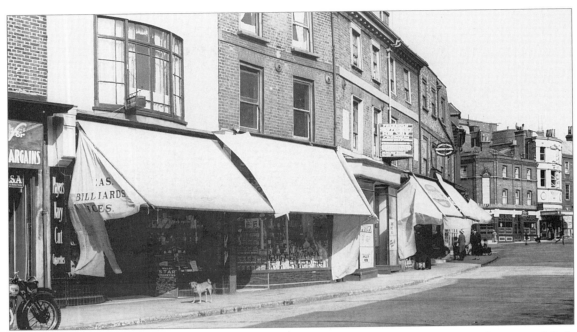

Stockwell Street, Greenwich, looking towards Crooms Hill, 1937. This photograph captures the street while it was still part of Greenwich's shopping centre. Only nos 1–3, alas not in the picture, survive today. The shadow cast by more shops on the opposite side of the street suggests that it has been a hot sunny day. A dog stands in contemplation of the confectioner's awning. Bombing and redevelopment have considerably altered Stockwell Street. Across the road from the hairdresser's we find ourselves on familiar territory. The Rose and Crown public house, rebuilt in 1888, is on the corner of Crooms Hill. Next door is the Greenwich Hippodrome Picture Palace with an entrance from the time when it was a music hall. In 1969 this building was rebuilt with a modern entrance to become Greenwich Theatre. Although the theatre has been extremely successful, because of a change in grant allocations it was forced to close in 1998.

Greenwich Market, 1990s. Built in 1831 as a general market, by the middle of the twentieth century it had become a fruit and vegetable wholesale market. Since 1984 it has been well-known for its 'arts and crafts' stalls and the specialist shops built in the old fruit and vegetable 'lock-ups' around the edge of the main courtyard.

94

Cultural Diversity

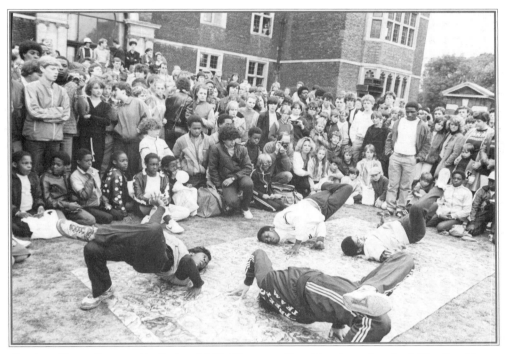

Charlton House Community Centre, 1983. The magnificent Jacobean façade of Charlton House is a curious backdrop to this break-dancing competition. Since the Second World War Charlton House has been used as a community centre, and the garden has been the scene of many fairs, fêtes and sales.

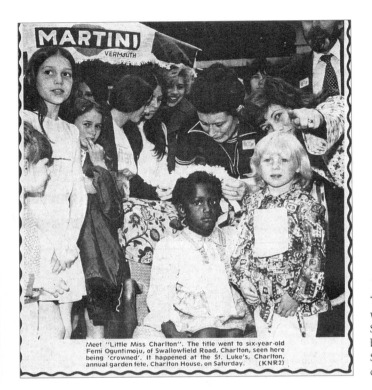

Meet "Little Miss Charlton". The title went to six-year-old Femi Oguntimoju, of Swallowfield Road, Charlton, seen here being 'crowned'. It happened at the St. Luke's, Charlton, annual garden fete, Charlton House, on Saturday. (KNR2)

'Little Miss Charlton', July 1973. The title went to six-year-old Femi Oguntimoju of Swallowfield Road, Charlton, seen here being crowned. The event took place at St Luke's Church, Charlton, during the church's annual garden party.

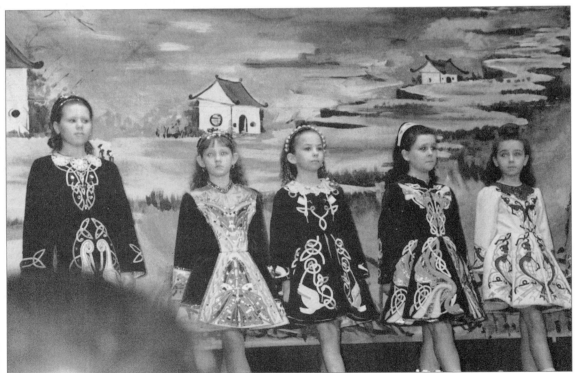

Irish dancing in Woolwich, 1990s. A demonstration of Irish dancing, part of multicultural Chinese New Year celebrations held in Woolwich Town Hall. The Irish came in great numbers to Woolwich in the nineteenth century seeking work, and again in the 1950s to work on postwar building schemes.

Refuge Assurance 6-a-Side, Pound Park, Charlton, 1996. Charlton Athletic Community Scheme was started in August 1992. The Pound Park Project caters for 5- to 15-year-old children. The scheme has six full-time staff including a woman responsible for 'Female football development'. There are, in addition, more than eighty part-time coaches.

Charlton Athletic Community Scheme, July 1998. Visit of Charlton Athletic Community Scheme to an Asian junior football club in Gravesend. The scheme is one of the largest in the country and Prince Charles accompanied the scheme on this visit. Coaches visit clubs and schools in the borough, neighbouring boroughs, and towns in Kent teaching basic football skills. There are, in addition, other projects run by the club such as the 'After Schools Club' and the 'Thames Gateway Project'. The latter organises activities for children in deprived areas.

Buffet supper for community leaders, 1971. Mayor Marie Kingwell and John Cartwright, MP for East Woolwich, talk to guests inside the Town Hall of the London Borough of Greenwich in Wellington Street, Woolwich.

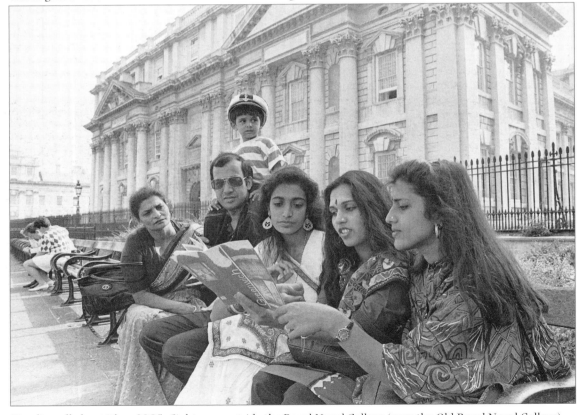

'Reading all about it', *c.* 1985. Sightseers outside the Royal Naval College (now the Old Royal Naval College).

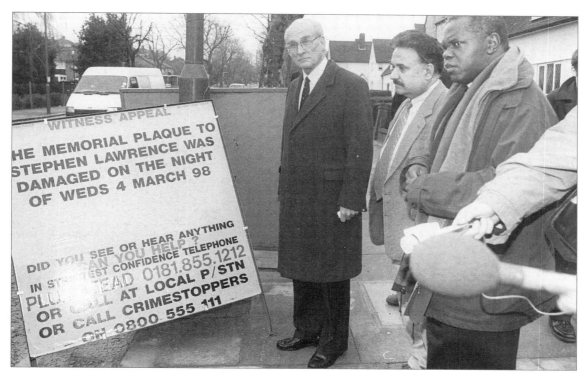

The Stephen Lawrence Memorial, Well Hall Road, Eltham, 1998. On 22 April 1993 a black teenager, Stephen Lawrence, was stabbed to death by a gang of white youths at a bus stop in Well Hall Road, Eltham. Six years later no one has been convicted of his murder although five youths were arrested. The criminal action against the youths failed as did a civil action brought by the parents Neville and Doreen Lawrence. A memorial plaque placed on the site of the murder in April 1995 has been vandalised twice: once in March 1998 and then again in February 1999. Here Sir William Macpherson (left) who chaired the government inquiry into the murder of Stephen Lawrence, and Revd John Sentamu, Bishop of Stepney (on the right) visit the plaque after it was first damaged in 1998.

The Stephen Lawrence Memorial, Well Hall Road, 25 February 1999. Neville Lawrence, Ros Howells (now Baroness Howells of St David's, Charlton in Greenwich), Cllr Bob Harris, Jack Straw (Home Secretary) and Doreen Lawrence looking at the plaque damaged on the day following the publication of the Macpherson Report.

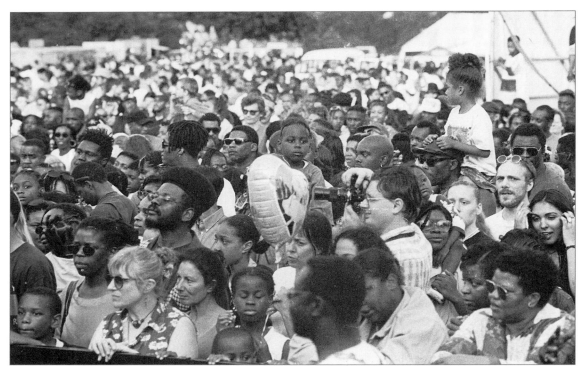

Anti-Racist Festival, Plumstead Common, July 1997. This very popular annual festival covers most of the Common, and there is a great range of stalls, activities and entertainments for everyone to enjoy. Many of Greenwich Council's services are represented. The high profile evening entertainment programme is particularly popular.

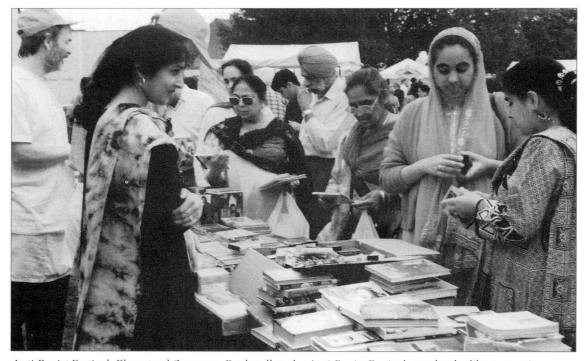

Anti-Racist Festival, Plumstead Common. Bookstall at the Anti-Racist Festival, run by the library service.

Greenwich Peninsula and the Dome

View of Greenwich Peninsula, *c.* 1965. This view from Vanbrugh Hill at the corner of Dinsdale Road features industrial Greenwich. The two gasholders of East Greenwich Gasworks are prominent. One of these was badly damaged by an IRA bomb in 1979. The damaged gasholder, the smaller of the two, was repaired and remains a conspicuous landmark today. It provides a striking contrast to the Millennium Dome which is its close neighbour on Blackwall Point. The undamaged gasholder was demolished in 1986.

Greenwich Wharf, *c.* 1910. This pair of photographs of Greenwich Wharf was taken by F. Sharp of 27 Trafalgar Road. The wharf is adjacent to Pelton Road in East Greenwich. The white material evident in both pictures is lime from the lime, slate and cement works which had been on this site. In the view looking west to the river wall the mast of a Thames sailing barge can be seen. A large part of this wharf was taken over by Lovells; Greenwich Wharf became a small area on the north of the site.

Riverside walk from Lovell's Wharf to Enderby Wharf, *c.* 1961. View of the riverside walk at east Greenwich. This walk was loved by Ian Nairn who said of it in 1966, 'God preserve it from the prettifiers'. Then the walk wound its way along a working riverside – a unique experience in London even then. The walk has been 'prettified' since and many of the wharves and businesses have either gone out of business or radically changed their use. However, it is still a fascinating experience to walk along this section of riverside with its astonishing views of the river, the Royal Naval College and Greenwich Park.

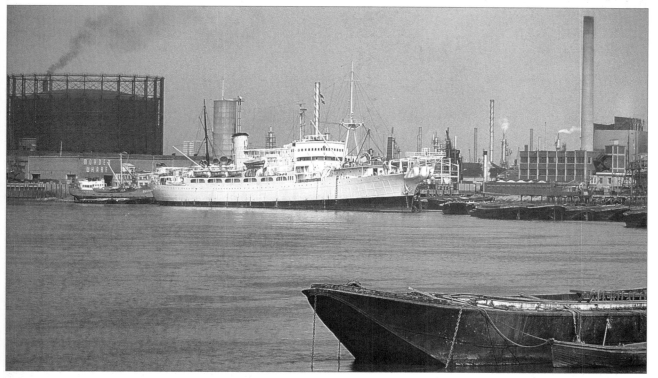

River Bank, Greenwich Peninsula, *c.* 1970. These wharves and factories on the western side of the peninsula were part of Greenwich's industrial heartland. The gasholder stands beside the northern end of Tunnel Avenue and was once part of the giant East Greenwich Gasworks, one of the largest in Europe. The gasworks has now gone and the Millennium Dome stands on part of the site. Here Morden Wharf, Tunnel Refineries, Telcon Cable Works (now Alcatel), and a cable-laying ship at Enderby Wharf can be seen. The lighters are moored off Piper's Wharf.

South Metropolitan Gas Company, East Greenwich Works, *c.* 1930. Men shovelling coal into the coking ovens. Two of the end products of their hard work were coke and tar.

South Metropolitan Gas Company, East Greenwich Works, *c.* 1930. The gang have downed shovels and cheerfully face the camera wearing clean white shirts not usually associated with coal stokers.

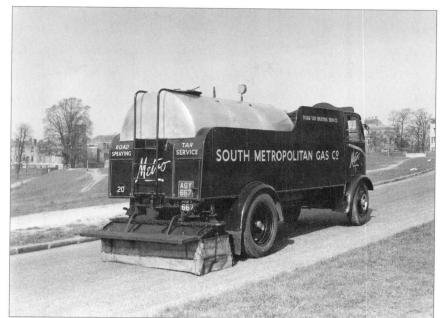

Tar lorry on Blackheath, 1933.
A South Metropolitan Gas Company tar lorry spraying tar on Cade Road on Blackheath. This was one of a fleet of lorries operated by the South Metropolitan Gas Co. for resurfacing roads with tar, a byproduct from the giant gasworks at east Greenwich (now the site of the Millennium Dome). The two elegant houses that can just be glimpsed on the right are the White House and Park Hall at the top of Crooms Hill.

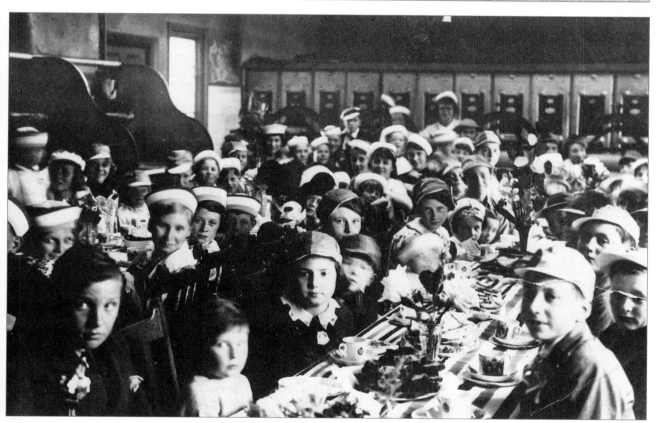

The Mission Hall, South Metropolitan Gas Co., Greenwich Peninsula, 1937. The children of Blakeley Buildings, Tunnel Avenue, were treated to a Coronation Tea in the Mission Hall. The hall also contained wash tubs, dryers and baths in cubicles. Washing was taken in great quantities to and from the so-called Mission Room, and the children had baths at a penny a time.

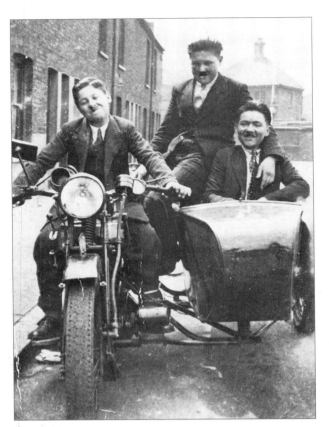

Ordnance Crescent, Blackwall Point, 1939. Ordnance Crescent stood immediately to the east of the entrance to the first Blackwall Tunnel. It took its name from the Blakeley Ordnance Works, which had been built at Blackwall Point in the early 1860s. The company also built a wharf, later named Ordnance Wharf. Although the factory failed, housing for their workers which had been built slightly to the north of Ordnance Crescent survived. The happy group in this picture lived in the industrial heartland of Greenwich. They are outside the Ordnance Crescent home of 15-year-old David Middleton who is perched on the sidecar. The BSA motorbike belonged to his family, but it is his 14-year-old friend Frank Dominey who is sitting on it in this picture. Another friend Jack Porter, the same age as Frank, is in the sidecar. On a recent visit to the site of the Millennium Dome Frank Dominey said, 'It feels strange knowing that this is the place where I lived and played throughout my youth.'

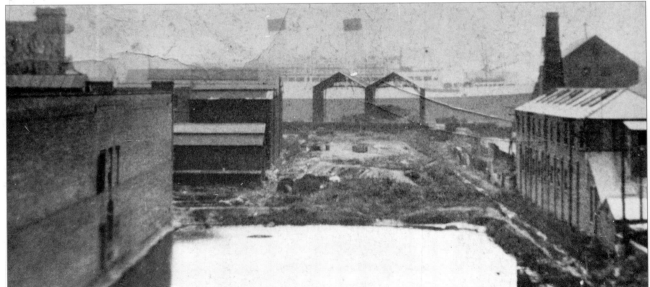

The Monte Pascoal from Greenwich Peninsula, c. 1936. This German cruise liner is snapped by the photographer sailing down-river on her way to Hamburg. The ship is seen passing between Greig's Wharf and the Greenwich Inlaid Linoleum Works just before sailing round Blackwall Point. In August 1933 the Hamburg–American Line began to run pleasure cruises between Greenwich and Hamburg. On the first trip it was estimated that about 800 passengers disembarked at Greenwich. About 500 passengers embarked at Greenwich for the six-day trip back to Germany. This picture was taken from the top floor of Blakeley Buildings, off Tunnel Avenue in Greenwich.

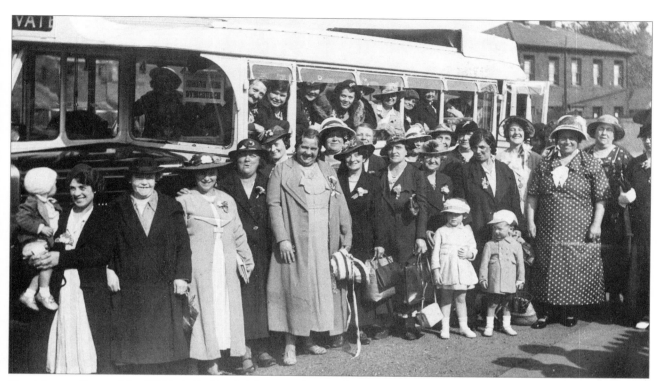

Day trippers. Greenwich, 1937. A 'Ladies Only' outing from Ordnance Crescent and Blakeley Buildings on the Greenwich Peninsula to Dymchurch. Timpsons of Catford supplied the coach. This part of the peninsula today has no resident population.

Footpath from the Thames to Tunnel Avenue, c. 1980. The runner has turned off the riverside path and is passing storage tanks belonging to Hays Chemicals. Their offices in Blackwall Lane and other property towards the river once belonged to the Molassine Meal Works which produced animal foods. 'Vims – all dogs love them' advertised one of their best-known products. The smell from the molasses seemed to permanently pollute the atmosphere.

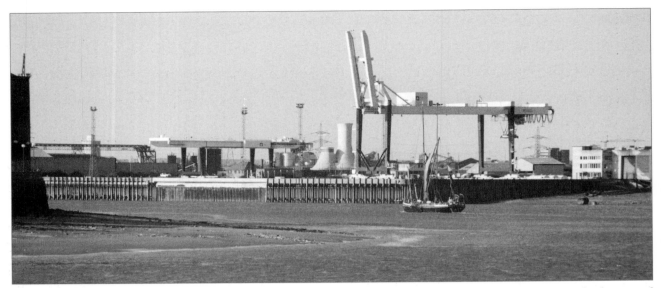

The Victoria Deep Water Terminal on the north-west side of the peninsula is seen from the river. This was a high point of the riverside path – an unnerving walk through a working container terminal with huge containers suspended from gantries above your head. Fierce warnings kept you to a marked path through the wharf. The terminal, which opened in 1970, didn't operate at its full potential and closed in 1987.

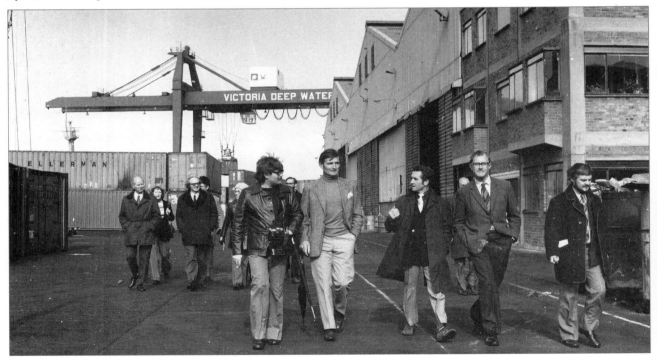

The Riverside Walk, Greenwich Peninsula, October 1975. Julian Watson, at front right, and Barbara Ludlow who is at the back on the left, are guiding officers and members of Greenwich Council's Recreational Services Committee along the riverside path from Victoria Wharf to the *Cutty Sark*. In the front row from left to right are: Cllr Derek Penfold, Christopher Field, Director of Recreational Services, Cllr Jim Gillman and Harry Davies, Chief Librarian. New signs had been made for this unique riverside walk, and some refurbishment had been carried out for European Architectural Heritage Year. One of the attractions of the walk was the section through the working container terminal at Victoria Wharf. Walkers were supposed to follow the yellow lines which marked the route through this exciting but potentially hazardous site. This group is, by and large, ignoring the lines!

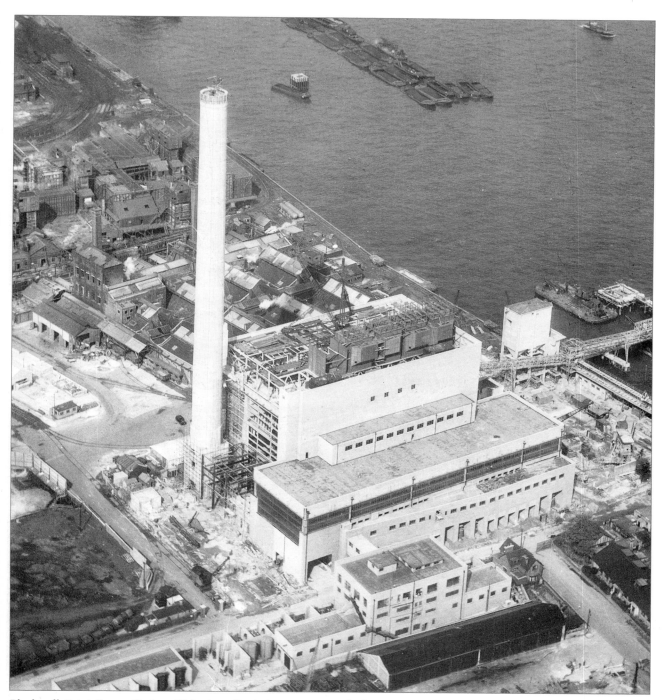

Blackwall Point Power Station. This short-lived power station which stood at the end of Riverway on the peninsula was acknowledged to be a fine piece of industrial architecture. It was built 1951–3, ceased power generation in 1981, and by 1989 was demolished. The Millennium Dome has been built just to the north of the power station site. On the south side of Riverway were the administration and amenity buildings of the station with a bridge connection over the road. This was one of four riverside power stations: Deptford, Greenwich, Blackwall Point and Woolwich. With the exception of Greenwich all have been demolished.

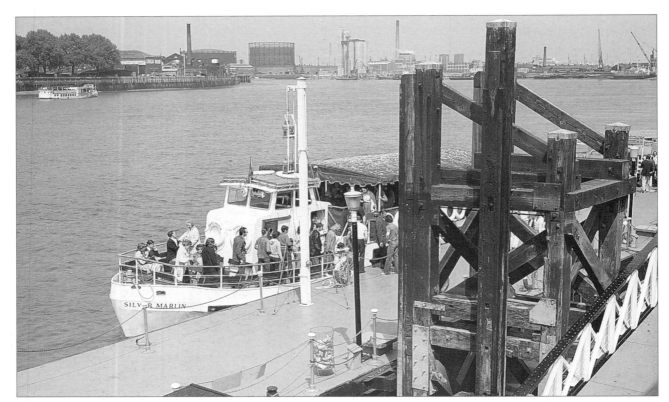

Tourists at Greenwich Pier, *c.* 1985. The hustle and bustle of merchant ships, tugs and lighters has almost disappeared, and the river has become the home of pleasure and leisure craft. The Isle of Dogs is about to be redeveloped but Greenwich Peninsula still looks like an area of busy industrial activity.

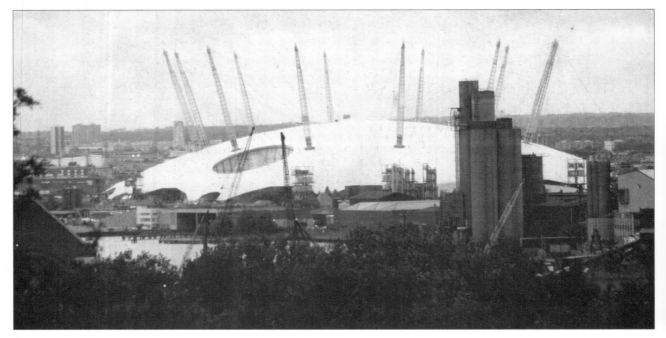

The peninsula from Greenwich Park, 1998. The Millennium Dome dominates the peninsula in this photograph by Keith Ward, overpowering even the large silos of Tunnel Refineries.

Leisure and Entertainment

Hockey Club outside the pavilion in Charlton Park, 1926/7. The old Charlton Hockey Club was formed in 1908. At first they played on a sports field in Weigall Road, Kidbrooke. No matches were played during the First World War, and when the team reformed they played their matches on Blackheath. In 1921 they united with the Old Charlton Cricket Club and Sir Spencer Maryon-Wilson, who still owned Charlton Park, provided them with a pitch there. In 1925 Greenwich Borough Council bought Charlton House, the park, and the formal gardens. The club continued to play there until the outbreak of war in 1939. The club did not reform after the war and no more Hockey Club games were seen in the park.

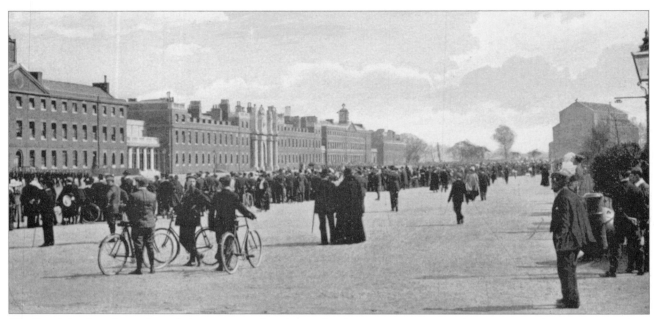

The Royal Artillery Barracks and the Garrison Church, Woolwich Common, *c.* 1910. These local people milling around on the parade ground are watching the Sunday Church Parade. The Royal Artillery Barracks were built between 1778 and 1802 with the Garrison Church being added later in 1863. Unfortunately this beautiful church was bombed in 1944. The ruins have been preserved as a memorial. Occasionally open air services are held there.

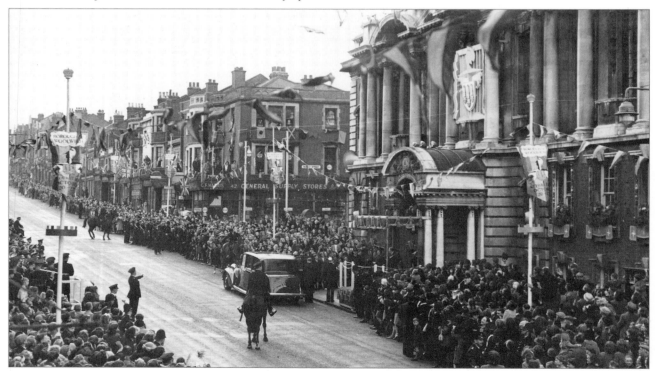

The Royal Regiment of Artillery receives the Freedom of the Borough of Woolwich, June 1954. Crowds line the street to see the Master Gunner, Field Marshal Lord Alanbrooke, accept the casket and scroll conferring the Freedom of the Borough on the Regiment of Artillery. The Mayor, Councillor J.W. Andrews, conducted the ceremony from a dais above the entrance to the Town Hall in Wellington Street. The regiment was founded in the Arsenal at Woolwich in 1716.

Royal Artillery Theatre, Woolwich Common. The Royal Artillery Theatre was built in 1863 as an officers' mess. It was converted into a regimental theatre but eventually opened as a commercial enterprise. Many well-known actors performed at this popular theatre. This programme features a play by Arnold Ridley who much later achieved fame as Private Godfrey in *Dads Army*. The theatre closed in 1956 and was later demolished.

The Mitre Public House, Woolwich. The Mitre stands close to St Mary's Church and overlooks the Woolwich Ferry. It is still the 'local' for the staff of the ferry. For a brief time when Thomas Henry Cribb was the landlord it was known as the 'Tom Cribb' after Thomas Henry Cribb's famous ancestor who was the only English boxer to be made champion for life. Cribb, the most famous and successful of all English boxers, is buried in the churchyard adjacent to the Mitre. There is a splendid stone lion in the churchyard that was paid for by Woolwich people to commemorate the career of the great boxer who died in 1848. The Odeon cinema in John Wilson Street was opened in 1937 and closed in 1981, only to reopen in 1983 as the Woolwich Coronet.

Right: St John's Football Club, 1908/9. The proud cup-winning team from St John's FC, Earl Rise, Plumstead, pose proudly for the cameraman. St John's Church was built in 1884 but destroyed in the Second World War. A new church was built on the same site in 1960.

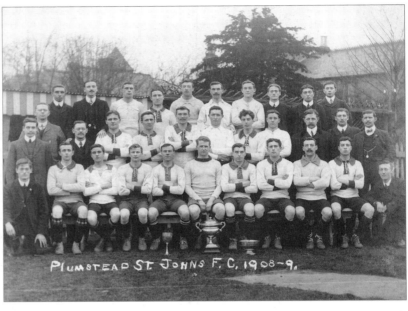

Woolwich Hippodrome, 1909. The poster advertises performances at the Hippodrome Variety Theatre in Wellington Street, Woolwich. This theatre, next to the Town Hall, was originally the Grand in 1901. It became a cinema in 1923, was closed for an expensive refurbishment in 1939 but never reopened. It was demolished in the same year, and it was not until 1955 that the Regal cinema opened on the site.

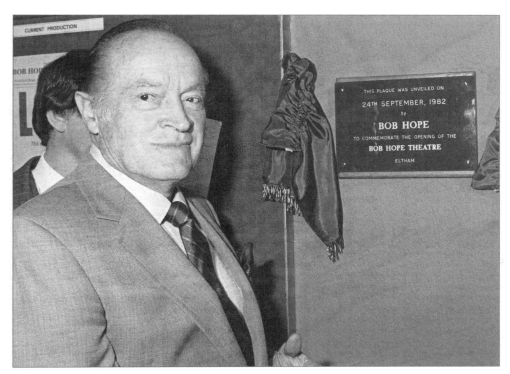

Bob Hope in Eltham, 1982. Bob (Leslie Townes) Hope was born at 44 Craigton Road, Eltham, in 1903. Two years later his family moved to Weston-super-Mare, and then emigrated to the USA. Bob Hope visited Eltham in 1982 to open the refurbished Eltham Little Theatre which had been renamed the Bob Hope Theatre.

Entrance to Eltham Hall, Eltham Palace, 1998. In 1933 Sir Stephen Courtauld acquired the lease of Eltham Palace. He restored the fifteenth-century Great Hall, repaired the moat and landscaped the gardens. At the same time he built a lavish new house adjoining the Great Hall which he and his wife used as a drawing room. The Courtaulds surrendered the lease in 1944 and moved to Scotland. The lease reverted to the Crown and, in 1945, the whole site was taken over by the Royal Army Educational Corps. The Ministry of Defence allowed public access to the Great Hall and part of the grounds but not to the Courtauld House. The site is now managed by English Heritage which has restored and refurbished the Courtauld House. This fascinating house with its splendid art deco entrance hall was opened to the public in 1999.

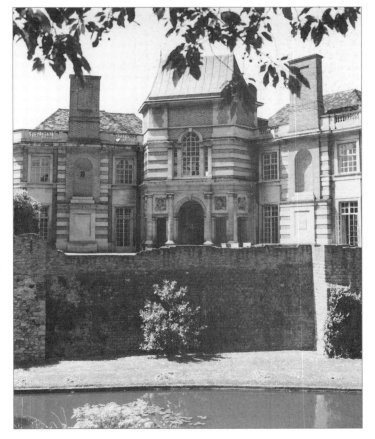

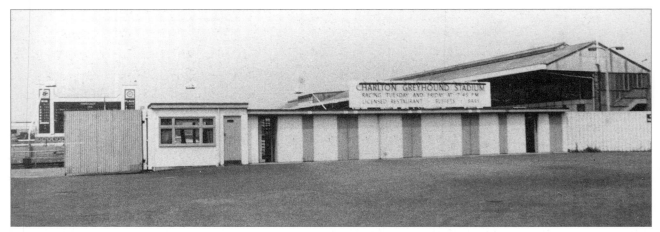

Charlton Greyhound Stadium, 1972. 'Going to the dogs' was a favourite pastime for many people after greyhound racing was brought to England in 1926. Charlton Stadium, on the north of the Woolwich Road near Anchor and Hope Lane, was opened in 1930. The Charlton track had the first electric hare in south-east London and, within months of opening, the first mechanical 'Totalisator' (Tote). Major races included the Blackheath Cup, the Charlton Hurdles, and the Greenwich Cup. Throughout the Second World War the stadium was only open on Saturday afternoons. It closed in 1962, only to reopen in 1966. However, its sporting life was short and greyhound racing finally finished at Charlton in 1971. The land was sold for redevelopment and Makro's store now occupies most of the site.

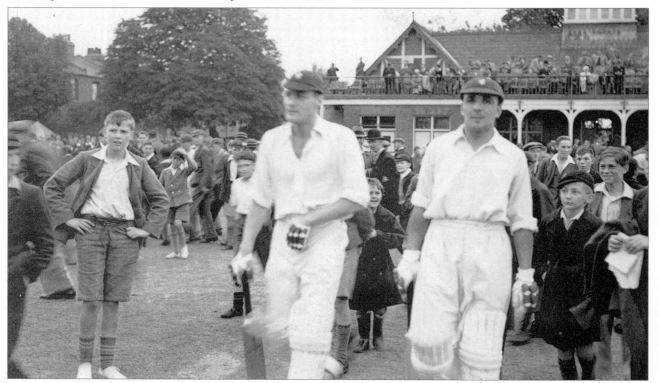

Kent v Surrey at Rectory Field, Charlton Road, Blackheath, July 1934. Here Leslie Ames, first right, and A.M. Crawley are seen going out to bat for Kent in the county's once-a-year match at the Rectory Field. From 1889 to 1970 Rectory Field hosted a Kent versus Surrey annual game. This delighted local cricket fans who turned it into a festive affair, a community event where friends and neighbours got together. Leslie Ames, wicket keeper and batsman, played for Kent from 1926 to 1951. Between 1929 and 1939 he also played for England. A.M. Crawley was a Kent player from 1927 to 1947. On this day Surrey were beaten by four wickets and the local paper called it 'Kent's magnificent win at Blackheath'.

Excavation of the Romano-British Temple in Greenwich Park, 1902. In 1902 Herbert Jones, seen in the picture with his wife, and A.D. Webster, the Superintendent of Greenwich Park, excavated a mound on the east side of the park not far from the Vanbrugh Gate. Although they found a considerable collection of coins, part of an inscription, and part of a statue they could not draw any firm conclusions about the building. In 1978 Harvey Sheldon and Brian Yule from the Museum of London carried out a more systematic excavation and concluded that it could be a Romano-British temple. The evidence, however, was not conclusive. In July 1999 the *Time Team* led by TV personality Tony Robinson surveyed the site and spent three days excavating it again. Evidence of a much larger complex was discovered plus very significant finds including part of an inscription. The interpretation of the site may well fundamentally change as a result of this dig. The report, however, was not available in time for the publication of this book.

Green Man Public House, Blackheath, 1970. Originally built in about 1629 the Green Man always benefited from its position on the main London to Dover road. It was more than just a public house, offering many forms of entertainment, and became a nationally important boxing centre. It was rebuilt in 1868–9 and, unfortunately, demolished in 1970. Towards the end of its life it hosted successful old time music hall performances which raised funds for the creation of Greenwich Theatre. Alison Close stands on the site.

The Great Storm, 16 October 1987. Even those fortunate people who slept through the devastating October storm will never forget the aftermath. The destruction of trees was dramatic as can be seen here in this photograph of Frank Dominey standing by a fallen tree at Folly Pond by the gate to Greenwich Park. More astonishing was the sight of houses, which had not only lost their roofs but also all the roof timbers. This is clearly shown below in the photograph of Vanbrugh Park where the roof of a large Victorian house has been neatly sliced off. Those who stayed awake through the ferocity of the storm found it an awesome and intimidating experience. There were some curious survivors: Queen Elizabeth's oak in Greenwich Park, a survival from Greenwich's medieval woodland, survived the storm, only to fall over a few years later in a shower of rain.

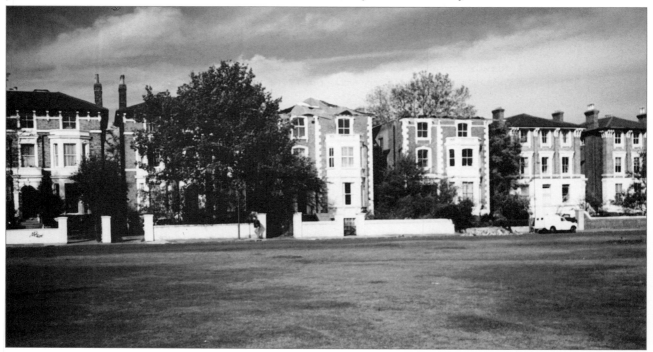

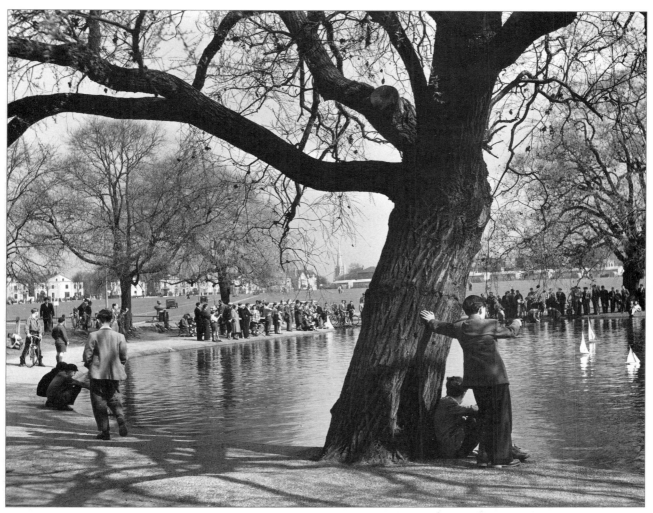

Prince of Wales Pond, Blackheath, *c.* 1950. Leisure pursuits change over the years. The model boats seen in this picture have largely been supplanted by sophisticated remote-controlled power craft. Model boat clubs used the pond and serious-minded members glowered at children who didn't take the pursuit seriously enough. Rarely does a crowd such as this stand around the pond today. In the background LCC prefabricated houses line the edge of Blackheath opposite St German's Place. As the housing situation improved the bombed-out families were rehoused and, eventually, all the temporary buildings were removed.

Marr's Ravine, Blackheath. *c.* 1905. This enormous gravel pit opposite Eliot Place was just one of several large excavations which gave the heath in Victorian times a markedly different aspect to the largely flat grassy area that we see today. Blackheath gravel was a much sought after commodity in the eighteenth century and the great pits on the heath were the result. Of the larger pits only Blackheath Vale and the Vanbrugh Pits survive today: Marr's Ravine was filled in 1908, and most of the others were filled in with London's bomb rubble in the Second World War. This photograph was taken not long before the pit was filled in.

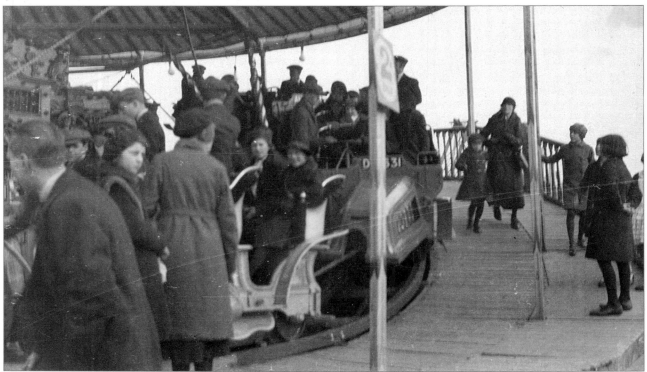

Blackheath Fair, Easter 1934. The Blackheath funfairs are civilised versions of much larger and more disorderly predecessors. The old Blackheath Fair was abolished in 1872 but large pleasure fairs continued on the heath and were a source of great enjoyment for Londoners. The fairs in the 1930s were much larger than their modern equivalents and even made use of one of the large gravel pits near Greenwich Park. This pit was filled in with bomb rubble during the Second World War.

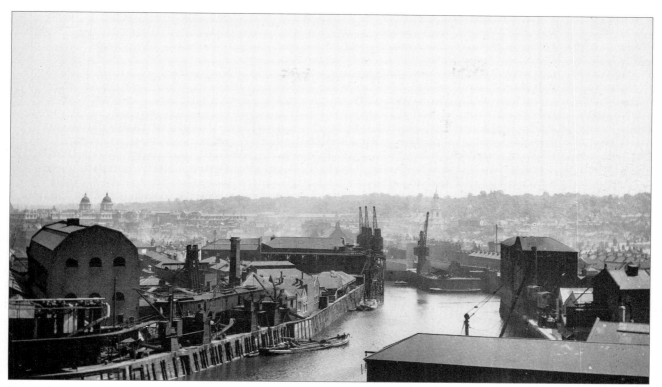

Deptford Creek and Greenwich, 1924. This view is from the roof of Deptford Power Station in 1924. Smoke from industry and houses was a major factor towards a good 'pea-souper'. It was brought to a head in 1952 when smog killed some 4,000 Londoners. The Clean Air Act of 1956 got rid of the worst of the pollution.

A century of architecture in Trafalgar Road, Greenwich, *c*. 1965. The oldest buildings in this photograph stand between the advertisement for Embassy cigarettes and a small block of modern flats. Four small mid-nineteenth-century houses, converted into shops later in the century, are about to be demolished. The cupola of Meridian School, formerly Old Woolwich Road School, stands above the walls of the power station. The school, built by the London School Board, was opened in 1888. Hardy Cottages, built by the London County Council in 1902, hide behind the 'Promise of Mackeson' advertisement. In recent years these cottages have been refurbished and now make a very attractive group. The hoardings have gone and a narrow lawn fronts the buildings. Two of the four chimneys of Greenwich Power Station tower over Old Woolwich Road. The power station was built in 1906 to supply electricity for the LCC tramway network. It now supplies power to London Underground. The grass-covered bombsite on the corner of Trafalgar Road and Eastney Street is now part of a public car park. The flats next to the old houses were built in 1963 and named Palliser House after Admiral Sir Hugh Palliser, the Governor of the Royal Hospital for Seamen at Greenwich, 1780–96.

Granada cinema, Trafalgar Road, Greenwich, 1994. The Granada opened on 30 September 1937 with *Midnight Taxi* and closed on 8 June 1968 with *The Oldest Profession*. Since its closure as a cinema it has been a bingo hall and a night-club. Its latest incarnation in 1999 is as luxury flats with leisure facilities.

Glaisher Street, Greenwich, 29 May 1953. Glaisher Street was a small turning off the west side of Straightsmouth close to Greenwich station. Only the street name survives today, commemorating James Glaisher's association with Greenwich and, particularly, the Royal Observatory. In 1953 the inhabitants of the eighteen houses in this short street enjoyed celebrating the Coronation of Queen Elizabeth II.

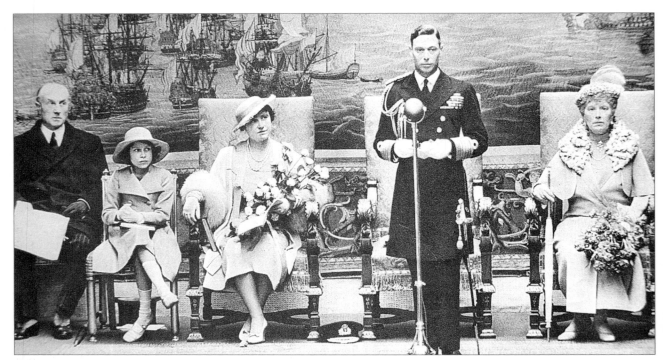

The opening of the National Maritime Museum, 27 April 1937. This photograph of the official opening of the National Maritime Museum at Greenwich shows from left to right: Sir Samuel Hoare, Princess Elizabeth (Elizabeth II), Queen Elizabeth (now the Queen Mother), George VI, and Queen Mary (then the Queen Mother). Between 1933 and 1937 the Queen's House was restored and the old naval school was converted into buildings suitable for the new museum. In the 1990s the Neptune Hall, one of the principal display areas, became sixteen new galleries with a huge upper courtyard. Sixty-two years after the opening of the museum Queen Elizabeth II returned to open the new exhibition areas.

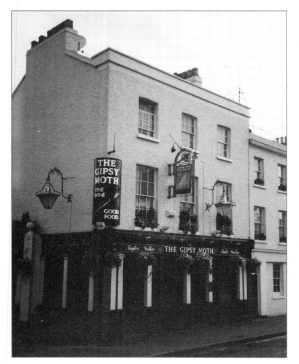

The Gipsy Moth public house, Greenwich Church Street. Sir Francis Chichester's yacht in which he sailed single-handed around the world was brought to Greenwich in 1968 and dry-docked at Cutty Sark Gardens. Across the way is a public house dating from about 1795. It was originally called the Wheatsheaf. In 1925 the Wheatsheaf was described as having 'an antiquated rough-cast frontage, a swing sign post and an old-fashioned outer lamp'. Many alterations have been made to the building since 1925. The old name no longer related to the area and in 1973 it was changed to the Gipsy Moth.

Nelson Road and King William Walk, c. 1969. In 1939 this shop on the corner of Nelson Road and King William Walk was a dairy and teashop owned by the Express Dairy and Co. Ltd. By the 1950s television sets began to appear in many living rooms. The Trafalgar Radio and Television Company helped to satisfy the demand for televisions when Queen Elizabeth II was crowned on 2 June 1953.

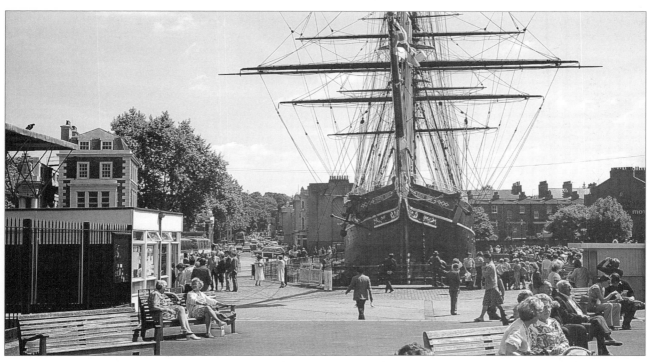

The *Cutty Sark*, Greenwich, c. 1985. The *Cutty Sark* clipper ship is one of Greenwich's main attractions. Many a visitor has stood on the prow imagining that they are sailing to the other side of the world to collect a cargo of tea or wool. The ship was built on the Clyde in 1869 and became very successful on the wool run from Australia. It was saved from an ignominious end and brought to permanent dry dock at Greenwich in 1954. In 1957 it was opened to the public.

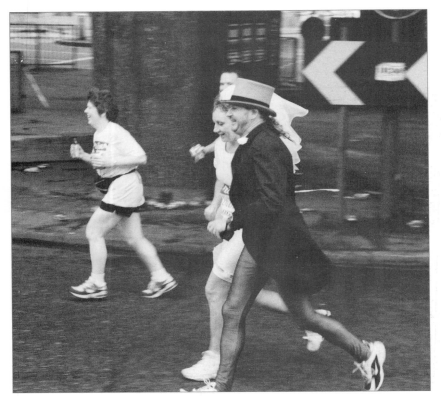

Flora London Marathon, 18 April 1999. The last London Marathon of the twentieth century! When Mick Gambrill and Barbara Cole ran out of Greenwich Park, dressed for a special occasion, they were still single. By the time they were snapped under the flyover in the Woolwich Road, they had become Mr and Mrs Gambrill. They ran into Charlton House, which is now licensed to perform marriages, did the deed and then ran back to join the thousands of other runners pounding the route to Westminster. The first London Marathon was in 1981, under the auspices of the Greater London Council. In the early races the runners came out of the Blackheath gate but, due to the immense popularity of the event, there are now other start lines on the heath. Since the demise of the Greater London Council private companies sponsor this massive fund-raising event.

Flora London Marathon, 18 April 1999. A very happy Jenny O'Keefe turns to wave and smile at her family and friends at the start of the Marathon on Blackheath. Jenny, a Senior Assistant Librarian at Greenwich Local History Library, said: 'This was home territory and I felt relaxed. It turned out to be a most enjoyable day and, five hours later, I collected my medal at Admiralty Arch tired but happy.' Jenny's successful run raised money for Epilepsy Research, just one of the multitude of charities which benefit from this event.

Countdown Clock, Royal Observatory, Greenwich. On 4 April 1997 the 'Greenwich one-thousand-day countdown clock', especially made by London watchmakers Accurist, began ticking away the milliseconds to the new millennium. It is attached to the wall of the Royal Observatory and is on the Prime Meridian of the world. At midnight on 31 December 1999 the countdown clock will be at zero and the twenty-first century will officially begin. However the position of the Royal Observatory, Greenwich, is that the new millennium does not start until 2001!

Acknowledgements

Many people have been kind enough to help us with the compilation of this book. Some have loaned precious family photographs, others have helped us with elusive dates or information not readily found in documents, and others have provided valuable information through their published books.

The majority of the pictures have been chosen from the large collection preserved in the Local History Library at Woodlands in Mycenae Road, Blackheath. The authors are most grateful to Greenwich Council for permission to select and reproduce from this very extensive collection and for the use of pictures held by other council departments.

The staff of the library, Jenny O'Keefe, Gwyn Roberts, Frances Ward and Caroline Warhurst, have been unstinting in their advice and support during the production of this book. Special thanks are due to Caroline for her help with editing and word processing in the final stages of producing the draft copy.

Grateful thanks are due to the following. We hope that we have included all who have helped.

Eric Allchurch (photographer)
Luke Anderson
Charlton Athletic Community Scheme
James Black
Betty Bird (née King)
Owen Boyle
M. Brooker (photographer)
Esther and Frank Dominey
Fay Gould
Greenwich Council's Communications Unit,
Public Services Directorate, and Graffiti Service
Greenwich Ethnic Library Service
Hugh Lyon
McDonald's Restaurants Ltd
Mary Mills
Tom Morris (photographer)
Neil Rhind
Geoff Robson (photographer)
Barry Saunders
Darrell Spurgeon
Trustees of the Martin Collection
Martie Volk (photographer)
Keith Ward (photographer)